IDIOT'S GUIDES

AS EASY AS IT GETS!

D1378991

Drawing
Pets

by David Williams

ALPHA

A member of Penguin Random House LLC

For Jessie, Beau, Perry, Bean, Max, Dre, and Chloe.

ALPHA BOOKS

Published by Penguin Random House LLC

Penguin Random House LLC, 1745 Broadway, New York, NY 10019., USA • Penguin Random House (Canada), 320 Front Street West, Suite 1400, Toronto, Ontario M5V 3B6, Canada • Penguin Books Ltd., 80 Strand, London WC2R 0RL, England • Penguin Ireland, 25 St. Stephen's Green, Dublin 2, Ireland (a division of Penguin Books Ltd.) • Penguin Random House (Australia), 707 Collins St, Docklands, Victoria 3008, Australia • Penguin Books India Pvt. Ltd., 3rd Floor Mindmill Corporate Tower, Plot No. 24A, Sector 16A, Film City, Noida, UP 201 301, India • Penguin Random House LLC (NZ), 67 Apollo Drive, Rosedale, North Shore, Auckland 1311, New Zealand (a division of Pearson New Zealand Ltd.) • Penguin Books (South Africa) (Pty.) Ltd., 24 Sturdee Avenue, Rosebank, Johannesburg 2196, South Africa • Penguin Books Ltd., Registered Offices: 80 Strand, London WC2R 0RL, England

Copyright © 2015 by Penguin Random House LLC

All rights reserved. No part of this book may be reproduced, scanned, or distributed in any printed or electronic form without permission. Please do not participate in or encourage piracy of copyrighted materials in violation of the author's rights. Purchase only authorized editions. No patent liability is assumed with respect to the use of the information contained herein. Although every precaution has been taken in the preparation of this book, the publisher and author assume no responsibility for errors or omissions. Neither is any liability assumed for damages resulting from the use of information contained herein. For information, address Alpha Books, 6081 East 82nd Street, Indianapolis, IN 46250.

IDIOT'S GUIDES and Design are trademarks of Penguin Random House LLC.

International Standard Book Number: 978-1-61564-817-7
Library of Congress Catalog Card Number: 2015930790

19 8 7 6 5 4

Interpretation of the printing code: The rightmost number of the first series of numbers is the year of the book's printing; the rightmost number of the second series of numbers is the number of the book's printing. For example, a printing code of 15-1 shows that the first printing occurred in 2015.

Printed in China

Note: This publication contains the opinions and ideas of its author. It is intended to provide helpful and informative material on the subject matter covered. It is sold with the understanding that the author and publisher are not engaged in rendering professional services in the book. If the reader requires personal assistance or advice, a competent professional should be consulted. The author and publisher specifically disclaim any responsibility for any liability, loss, or risk, personal or otherwise, which is incurred as a consequence, directly or indirectly, of the use and application of any of the contents of this book.

Most Alpha books are available at special quantity discounts for bulk purchases for sales promotions, premiums, fund-raising, or educational use. Special books, or book excerpts, can also be created to fit specific needs. For details, write: Special Markets, Alpha Books, 1745 Broadway, New York, NY 10019.

Trademarks: All terms mentioned in this book that are known to be or are suspected of being trademarks or service marks have been appropriately capitalized. Alpha Books and Penguin Random House LLC cannot attest to the accuracy of this information. Use of a term in this book should not be regarded as affecting the validity of any trademark or service mark.

Publisher: Mike Sanders
Associate Publisher: Billy Fields
Executive Acquisitions Editor: Lori Cates Hand
Development Editorial Supervisor: Christy Wagner
Cover Designer: Laura Merriman

Book Designers: Rebecca Batchelor and Laura Merriman
Production Editor: Jana M. Stefanciosa
Layout: Ayanna Lacey
Proofreader: Michelle Melani

contents

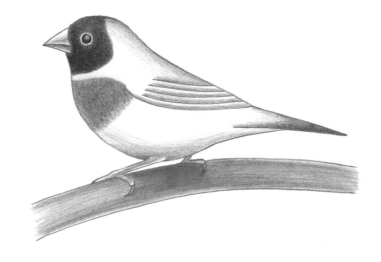

The Basics 2

setting up your drawing area . 4
helpful tools. 6
drawing techniques 8
drawing animal anatomy . . . 10

Gallery of Pets 12

mouse 14
frog 16
turtle 18
gerbil 20
hamster 22
gecko 24
iguana 26
finch 30
guinea pig 32
snake 36
rooster 40
chick 44
parakeet 48
african gray parrot 52
chinchilla 56
persian cat 60
yorkshire terrier 64

cocker spaniel 68
german shepherd dog 72
dalmatian 76
beagle 80
blue tang fish 84
hermit crab 86
clown fish 90
betta fish 94
goldfish 98
pony 102
horse 106
arabian horse 110
appaloosa horse 114
llama 118
puppy 122
labradoodle 124
kitten 128

maine coon cat 130
siamese cat 134
tuxedo cat 138
chicken 142
duck 146
cockatiel 150
tarantula 154
hedgehog 158
ferret 162
rat 166
sugar glider 170
macaw 174
calico cat 180
labrador retriever 186
saint bernard 192
american quarter horse . . . 198

introduction

Keeping a pet and caring for a living creature gives you special insight into animals and how you can draw them more realistically. As you work through the collection of 50 pets in this book, you'll learn about animals; discover how you can see shapes more clearly; and translate patterns of fins, fur, and feathers into lines and shading. The lessons in this book begin with easier drawings that progressively become more difficult, and with color showing old versus new lines so you know just what to draw. Along the way, new visual challenges and techniques are presented so you end up with the right shapes and textures.

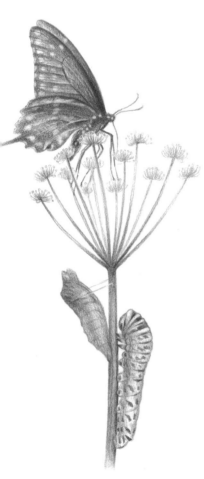

An animal becomes a pet when you make a home for it, and slowly it becomes a part of your world—and you a part of its. You consider how the animal feels and ensure it has what it needs for food, lighting, temperature, and a safe environment. Drawing a pet begins with spending some time observing it. It changes shape depending on your viewing angle. Its covering might consist of multiple textures and patterns. It has its own way of crawling, grasping, and moving that might have similarities to humans and also amazing differences.

Along with cats, dogs, and birds, I've always had an interest in butterflies and the way they move and fly, the shapes and colors of their wings, and how they change from a caterpillar to a winged beauty in stages. My young son and I had the chance to care for two little caterpillars once. We identified them through research on the internet as the larvae of the eastern black swallowtail butterfly. We built a habitat for them and placed fennel plants and a tree

branch inside based on what we learned from a book at the library. Their temporary home sat in my art studio near my easel, where I could see it while I worked, and so my son could learn firsthand about metamorphosis and how a larva becomes a butterfly. After a few days, each caterpillar had become a chrysalis and wrapped itself in a small case that hung from the branch. We talked about how the creatures were changing inside like a painting inside a studio.

We let them do what they needed to do, and we got on with our work. Weeks passed, a month went by, and then another, yet the two cases hung silently. When I wondered if something had gone wrong, I reminded myself metamorphosis sometimes takes months.

Then one day as I painted, I heard a very small sound like paper crinkling. I turned and saw a butterfly hatching from its chrysalis! I called my son over, and we watched them feed on nectar and saw their wings become strong. When they were ready, it felt good to set them free to be a part of the world outside.

The special insight you develop from caring for another living thing makes it fun to capture that personality in a drawing. I hope you're inspired as you follow the lessons and techniques in this book and that the drawings fuel your imagination for drawing your own pets—or pets you'd someday like to care for.

Acknowledgments

Organizing this wild romp with such a wide range of animals into concise lessons was made possible in great part by the creative team at Alpha Books. Thanks to Lori Cates Hand for giving me a fun challenge, ensuring the words ring true, and believing in the reader. High five to Christy Wagner, her creativity, and her insight into words and images, and to Laura Merriman, for making each page look great. Thanks also to my wife, Rachel, and son, Seth, for being a home for my heart and my inspiration.

the basics

When drawing an animal, it helps if you understand a few things about drawing techniques and also about animal bodies. An animal's movement and appearance is based on its skeleton, muscles, and body covering—whether that's fur, feathers, skin, scales, spines, or exoskeleton.

The drawing techniques I show you in the following pages help you complete the 50 pet drawings later in the book and are used frequently, like shading and erasing. Some will take a little practice, but once you learn them, you'll see they're really helpful in all kinds of drawing situations and for any animal.

You can make most of the drawings in this book with very few supplies: paper, a pencil, and an eraser. I also recommend a few other items that will help in different ways for artists of any age.

setting up your drawing area

You might be surprised to know that even things like lighting and where you sit influence the quality of your lines and shading, so if you can, think about where you'll draw. The following are suggestions to make drawing easier, but you might want to set up differently when you find the way that works best for you.

Sit at a table space that's wide enough to lay this book open with your drawing beside it—about 40 inches (1m) wide. Try your kitchen or dining room table. You'll also need a chair that's the right size for you so your feet rest flat on the floor and you can easily reach your drawing paper.

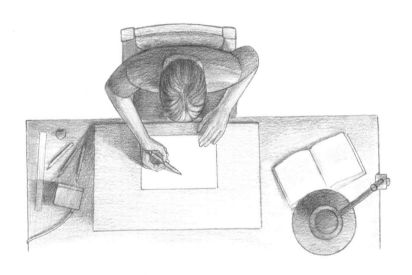

Be sure your lighting—whether it comes from a window, lamp, or light fixture—is angled so it doesn't reflect off your paper and make your work hard to see. You might have to pick another seat, turn your table, or get a different lamp to get it right. You can clamp a drafting lamp onto your table, for example, and adjust it to reduce glare.

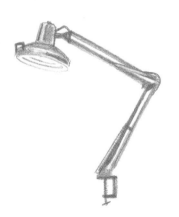

It's helpful to have enough light as you draw to clearly see the lines and tones without straining your eyes, so sit where you have bright enough light. A ceiling light fitted with two 60-watt bulbs or 23-watt compact fluorescent bulbs works well. If you attach a drafting lamp on the edge of your table, position it *opposite* your drawing hand so it doesn't cast shadows across your drawing. Also, position it above your head so it doesn't shine into your eyes while you draw.

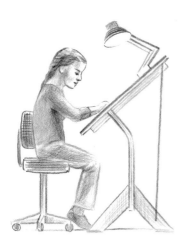 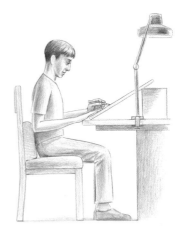

Angle your drawing paper toward your eyes about 30 degrees to avoid distorted shapes in your drawing that can happen when your paper is angled away from your eyes. To view your paper more directly, use an adjustable drafting table if you have one, or tape your paper to a smooth board leaning against a table and resting in your lap. You also can angle the board against a stack of books on top of a table. Fasten the bottom edge of the board to the table with masking tape to keep it from slipping.

A thicker home office printer paper (like 24-pound *bond*) is a good, basic drawing surface. It has a little texture (called *tooth*) for shading smoothly and takes erasing fairly well. Be sure you tape it down to avoid bending it. *Bristol paper* is thicker (100-pound), sold in art and craft stores, and is made in two surfaces: smooth and vellum. I recommend vellum for its great texture when you're shading light or really dark areas. When you erase, Bristol paper is less likely to bend or tear.

FUN FACT

When you buy printer paper for drawing, you might notice 24#(90g/m²) printed on the package in small print. The # symbol stands for pound weight and indicates that 500 sheets of this paper, called a *ream,* weighs 24 pounds. At the paper mill, the paper is first cut into 17 by 22–inch sheets before it's cut into standard 8½ by 11–inch sheets.

helpful tools

You don't need a lot of special tools to begin drawing pets. Pencil, paper, and eraser are the basics. You also can pick up some accessories if you like.

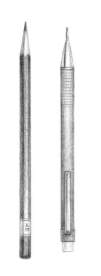

You can use any pencil when drawing, but as you gain experience, you might want to upgrade from your standard number 2 pencil. I use traditional wood-bound graphite drawing pencils. They require frequent sharpening, but they produce softer shading quickly and make a wider range of drawing effects—handy when drawing animals with different fur, feather, scale, and other coverings. The 4B pencil is fairly soft and produces dark tones as well as lighter ones when you apply different amounts of pressure. Common mechanical pencils, if you prefer, don't require sharpening, but they have thin lead in harder grades, so they can't produce the wide range of effects wood-bound pencils do.

Graphite is a dark mineral refined for drawing by mixing it with clay—more clay for lighter lines, and less clay and more graphite for darker ones. The letter and number on the side of a drawing pencil show the pencil's grade: *B* stands for *black,* or dark, and *H* is *hard,* or light. That number 2 pencil has more clay and won't produce the darker tones.

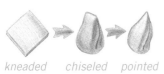

kneaded chiseled pointed

The kneadable rubber eraser is an amazing tool for drawing. Packaged in a small, gray block, this eraser is fairly soft so you can stretch, pull apart, and reshape (or knead) it. Use it to take away mistakes and lines you don't need but also to create special effects by pressing it into or dragging it across shaded areas. It will soften from the warmth of your hand and from kneading.

For general erasing, flatten one side of the eraser and lightly drag it over a mark or shaded area. When the eraser becomes shiny with graphite, it will slide around on the paper—these are two signs you should knead it and reshape it before continuing to erase. When you erase all the way to the white of the paper, you might find small eraser specks that can get in the way of future shading. Brush them away gently with a paper towel or a soft, wide paintbrush. Avoid brushing the drawing with your hand or blowing on it because both can smear the graphite. Also, avoid smudging while you draw by placing a piece of printer paper under your drawing hand.

To erase thin lines into a shaded area, such as with some of the whiskers you add to darker-shaded pets in the lessons, be sure the area is fairly dark. Shape the eraser between your thumb and index finger so it has a flat edge. Drag the edge of the eraser or lightly tap it in the direction of the line you want. Knead and reshape the eraser often, and continue the line at the point you left off.

To make round highlights, such as in the eyes of many of the pets, shape the eraser into a point by rolling it between your thumb and index finger. Then press the tip straight down into the paper and pull straight up. Knead the eraser, and repeat this to make the highlight lighter.

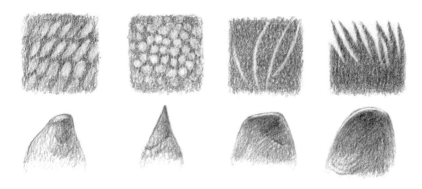

You can erase other inventive textures into a shaded area by shaping the tip and pressing or tapping it on your drawing. Try shaping the eraser into the tip shapes illustrated to make the textures shown here.

You can use a metal ruler to create reference or construction lines before you begin drawing and to compare lengths and proportions as you work.

I use an electric pencil sharpener that makes a long tip, exposing more lead for better shading. A handheld sharpener with a compartment for catching shavings is a less-expensive alternative.

drawing techniques

A few basic techniques are used to make the drawings in this book; they're useful for other kinds of drawing, too. In this section, you learn the importance of beginning a drawing so the parts are the right size, making lines and edges, shading, and creating textures.

Some lessons in this book begin with you drawing a box or lines. These marks help you determine the correct size for your overall drawing and ensure different parts of the drawing are in proportion. Make these shapes and lines very light so you can easily erase them later or so they blend into the shading you do over them. When I draw, I make these lines with the side of my pencil as if I were shading, or with the tip with very little pressure.

Also look for size relationships as you draw an animal. For example, use the height or width of the animal's head to determine the correct size of its body. The number of heads high an animal is changes depending on the animal's position in your drawing, so decide on a specific view before you start.

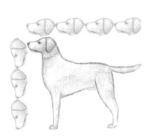

When you draw from a photograph or digital image, measure the width of the head with a ruler and then divide the entire width or height of the animal by that number. Or simply take the head measurement on a piece of paper and step that across the animal's body in the image and figure out how many steps it takes to span the distance. Determining sizes like this helps you see how each animal has a unique look that can be drawn much better with measurements.

You're asked to begin many of the drawings with a broken outline. These soft lines, or shading lines, are easier to incorporate into the final textures of the animal so you rarely need to erase them. Make them with small gaps to avoid details (like corners) because they're easier to change than a continuous outline. Each segment usually describes an angle of a side of the animal. Angles and sizes are much more important at the beginning of the drawing than details. Apply most details last for best results.

To create general shading, use a back-and-forth motion with your pencil. Grip your pencil at about a 30-degree angle and simply move it side to side. Shade areas at one angle and then add a second layer (or pass) at a slightly different angle to fill in any white space and for even tone.

You also can shade by repeating single strokes very close together in one direction. As you complete each stroke, gradually lift your pencil off your paper to create a soft end to the stroke. This produces softer shading effects.

A *gradation* is shading from dark to light. Create the darkest tones of a gradation in multiple passes for even tone. The lightest tone may be the white of the paper or a very pale tone made with very little shading pressure.

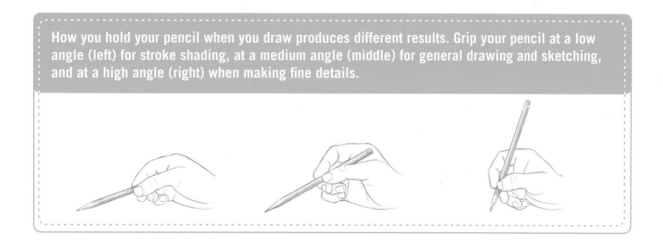

How you hold your pencil when you draw produces different results. Grip your pencil at a low angle (left) for stroke shading, at a medium angle (middle) for general drawing and sketching, and at a high angle (right) when making fine details.

Here are the main steps to drawing an animal:

1. Lightly draw tick marks, reference lines, or helpful construction marks. Sketch the main shapes lightly without details using soft broken lines.
2. Erase any leftover or visible construction marks.
3. Refine the outer edges (the *contours*) of the main shapes.
4. Squint to see dark areas and light areas of the image you're drawing from without all the small changes of tone and without details—save those for last! Shade the main dark and light areas.
5. Add textural effects like fur or hair, scales, claws, etc. Make small changes in middle tones.
6. Intensify the darkest areas, and erase highlights. Add the smallest details like whiskers, highlights, and final hair or feather texture.

drawing animal anatomy

Anatomy is a science that deals with the structures of bodies. The anatomy of an animal, its skeleton, and its muscle structure determines the shapes you see on the animal's outside. Understanding some basics of anatomy can help you make sense of where to place the legs, head, and eyes so the animal looks more real when you draw.

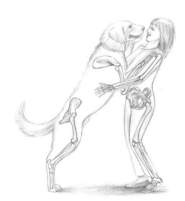

Comparing the skeletal (bone) anatomy of a dog to a human shows similarities and differences. This helps you better see an animal's anatomy in relation to one that's more familiar (your own!).

Animals with a backbone, or spine, are called *vertebrates* and include pets like chickens, dogs, cats, and snakes. Animals without spines, such as spiders, are called *invertebrates.* The spine is important when drawing some animals because it helps you know where to place the animal's arms and legs. A mammal's limbs attach to its pelvis or shoulder that, in turn, connects to its spine. The head is at one end of the spine, and the tail is at the other. All these bones connect to create a stable structure and a place for the animal's muscles to attach.

When you look at bones, you might notice they have unusual shapes. They have round ends where they rotate at the knee or shoulder, for example, and they have ridges and ends that protrude where tendons attach. The shapes of bones can influence an animal's outer appearance. A dog's skull has bumps on the top and around the eye you can see and feel. But some bones, like most of the spine, are buried inside layers of muscle. They, along with the muscles, work together to give the animal balance and the ability to move.

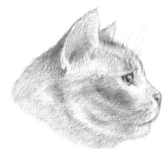

Animal skin, scales, fur, feathers, hair, and hard outer covering (the *exoskeleton*) have different textures and patterns of light and dark areas. When you draw an animal, you create the illusion of that texture with shading and lines. The animal's fur or scale patterns change direction, and your lines and shading will, too. Such knowledge helps you make sense of unfamiliar details as you observe animals and photos of them.

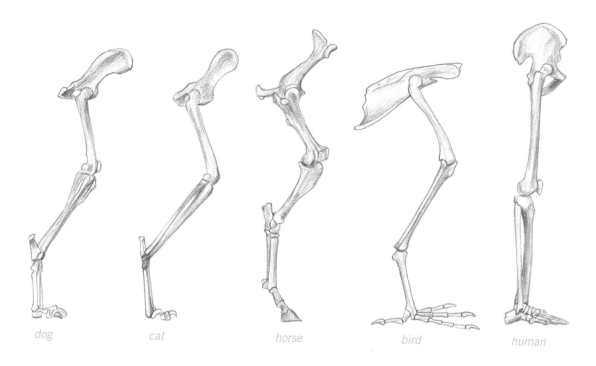

dog cat horse bird human

Look to the feet, paws, and toes of an animal to discover how they move and live. Reptiles like the iguana and gecko have toes for climbing or moving over rough, uneven surfaces. Amphibians, like the frog, have webbed feet for moving through water. A bird has feet for grasping branches, while the sugar glider can grasp branches and climb with its front and rear legs.

You can see subtle signs of how an animal lives by considering how they breathe and eat. The nostrils of the turtle, for example, are high on its head to allow for breathing and swimming close to the water's surface. The box turtle's mouth has a sharp tip for tearing apart vegetation—or in the case of carnivorous turtles, for tearing meat. Now think about horses. Their nostrils are wide for taking in large amounts of air while they run. Their teeth include incisors for tearing up grass and molars for grinding grain.

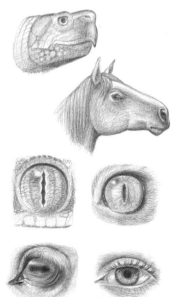

Some reptiles and cats have vertical pupils that allow them to see colors better in bright sunlight. Horses' pupils are horizontal, and humans' are circular.

So when you think about what pet you're going to draw, also consider their eyes, nose, mouth, bone and muscle structure, and these other anatomy basics. Details like these will make your drawing believable, and accurate structure will make it lively.

gallery of pets

The following lessons for drawing 50 pets cover a wide range of mammals, fish, reptiles, amphibians—even an arachnid!—and call for a wide range of drawing techniques. The lessons are grouped by difficulty level, from easier to more challenging:

- **Level 1** pets are drawn mainly with lines and have written tips to help you understand the shapes as you draw.

- **Level 2** pets are drawn with lines and include some shading. These lessons also introduce more unusual views of the animals.

- **Level 3** pets are created with a balance of line and basic shading techniques with more complexity and dynamic views.

- **Level 4** pets involve more difficult techniques of shading and erasing with richly patterned textures.

- **Level 5** pets show more movement, use layered shading and erasing, and have small details and many intricate parts.

When you decide on a pet to draw, take a moment to read through the instructions so you fully understand the sequence and how the drawn shapes are best positioned on your page. All the drawings can be made on standard letter size (A4) paper with a 4B pencil, a kneadable eraser, and an 8-inch (20cm) or longer ruler.

mouse

Steps: 5
Difficulty: ● ○ ○ ○ ○

A mouse's eye is shaped like a teardrop and is located halfway between the ears and the nose. Draw the more complicated parts, like the eye and the paws, with soft lines first to get the shape right and then darken them with a sharp pencil.

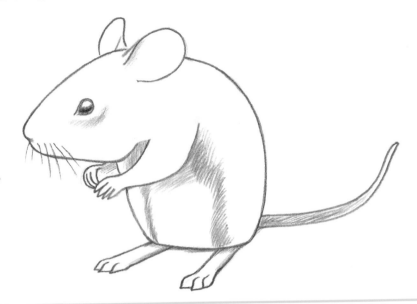

1 Draw the mouse's head. When you get to the nose, slow down to make a small bump. Add the ears.

2 Beginning at the ear, draw the body. Leave a gap for the front leg.

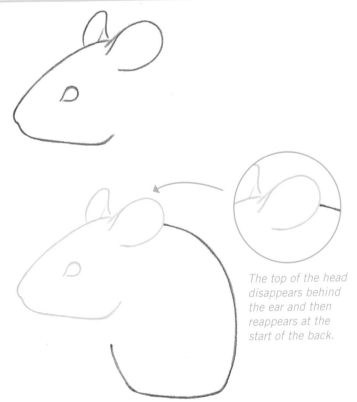

The top of the head disappears behind the ear and then reappears at the start of the back.

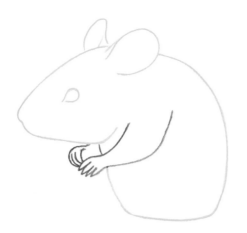

3 Draw the front leg and the paws.

FUN FACT

There are many types of fancy pet mice. Single-color mice are called *selfs;* those with distinct fur patterns are *marked; tans* have tan-colored bellies; and *satins* have shiny coats.

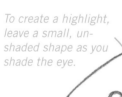

4 Draw pairs of angled lines for the back legs, and make the tail.

To create a highlight, leave a small, un-shaded shape as you shade the eye.

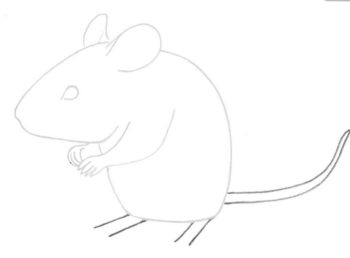

5 Complete the back paws with curved V shapes, add the whiskers, and shade.

frog

Steps: 5

Difficulty: ● ○ ○ ○ ○

Frogs' eyes sit at the top and sides of the head so the amphibian can see predators approaching while submerged in water. Copy the angle of the body and the legs carefully so the frog appears to sit on level ground.

1 Draw two shapes—one that resembles a top lip and angles down to the right and another that looks like a bent straw.

Draw the lip shape at this angle.

2 Erase several parts of the lip shape, as shown. For the back leg, draw a U shape opening to the right and then add another opening to the left for the front leg.

The back leg is slightly lower than the front leg.

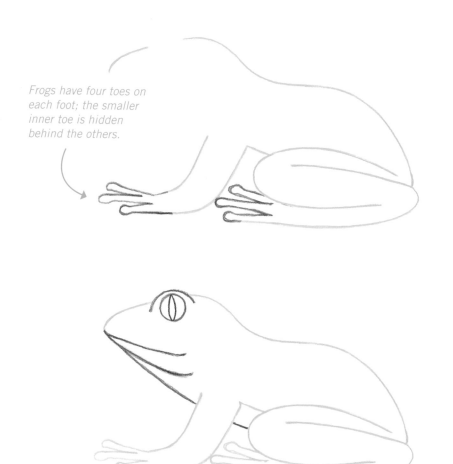

Frogs have four toes on each foot; the smaller inner toe is hidden behind the others.

3 Make three toes with round tips at the end of each leg.

4 Draw the eye, jaw, and belly.

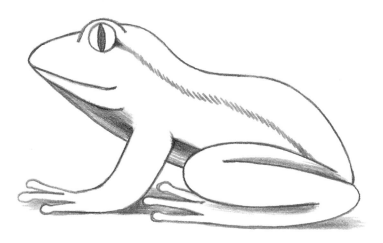

5 Shade the eye, belly, and legs, and add a shadow below the frog. Create a shaded stripe, using lots of short, angled lines, from the eye back along the body's contour.

turtle

Steps: 5

Difficulty: ● ○ ○ ○ ○

Box turtles, like this one, have forward-facing eyes that are high on their head and level with their nostrils. The shell patterns vary with yellow marks on a dark brown surface.

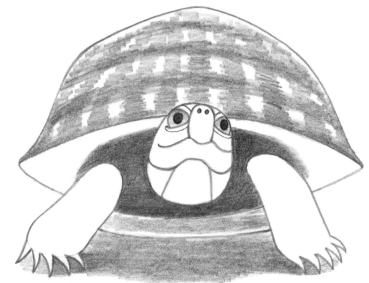

1 Draw a leaning oval, the upper shell shape, and the lower curve.

The shapes of the head and body look like an eye.

2 Erase two spaces on the lower curve, and draw the legs and feet. Add a line between them to represent the turtle's underside (called the *plastron*).

Each foot contains five toes made of curved V shapes.

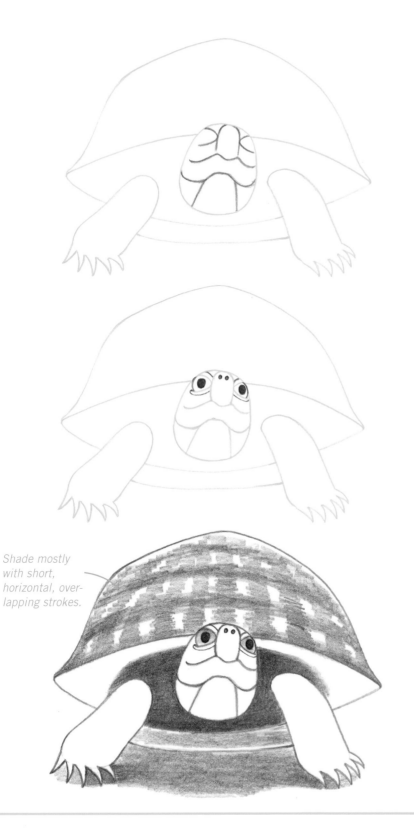

3 On the face, draw several U shapes and then add a flying-bird shape for the mouth.

4 Add the outer curves of the eyes, the pupils, and the nostrils.

Shade mostly with short, horizontal, overlapping strokes.

5 Shade the eyes and around the body. To create a shell pattern, shade overlapping vertical and horizontal stripes.

gerbil

Steps: 5

Difficulty: ● ○ ○ ○ ○

Compared to mice, gerbils have larger eyes; a thicker, hairier tail; and slightly longer fur. At the shading stage of your drawing, use short strokes for the fur and back-and-forth shading to create the shadows.

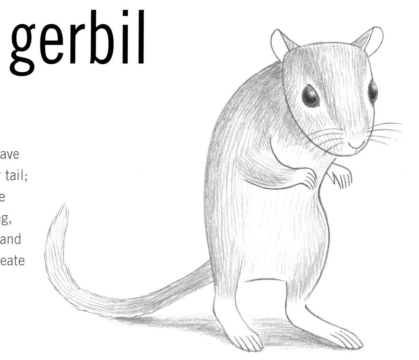

1 For the main outline of the head, draw a leaning oval with a less-curved top.

2 Add the ears, nose, and whiskers. Draw the eyes.

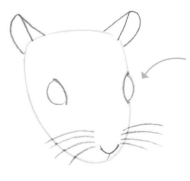

Erase a portion of the right side of the head shape before drawing the right eye.

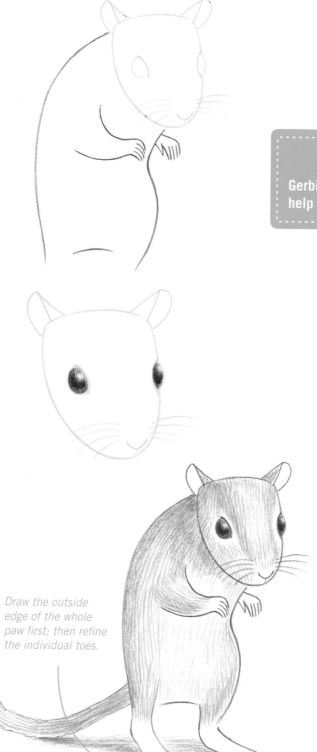

3 Draw the curves of the body, the front legs, and the paws.

FUN FACT

Gerbils have strong hind legs that help them leap and move fast.

4 Shade each eye and then erase a highlight.

5 Draw the hind legs and paws, and add the tail. Create the fur with short lines that change direction gradually with the body, and complete the shadow.

Draw the outside edge of the whole paw first; then refine the individual toes.

hamster

Steps: 5

Difficulty: ● ○ ○ ○ ○

Part of what makes a hamster so cute is her fluffy fur. Create the fur texture by shading and then erasing parts of that shading. By shaping your kneaded eraser in different ways, you can make all kinds of erased marks.

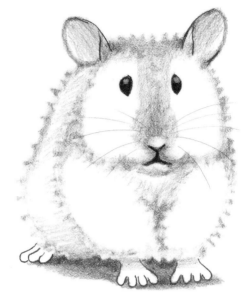

1 Shade a T shape with a wide base and then add two J shapes that attach to it.

Shade with the side of your pencil tip using a back-and-forth movement.

T shape

J shapes

2 Shade the ears and the hamster's thick body contours.

Where the front legs meet makes a small, rounded T shape.

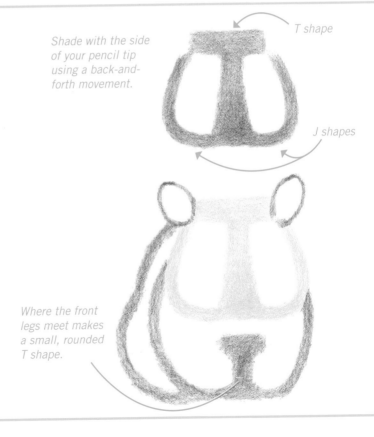

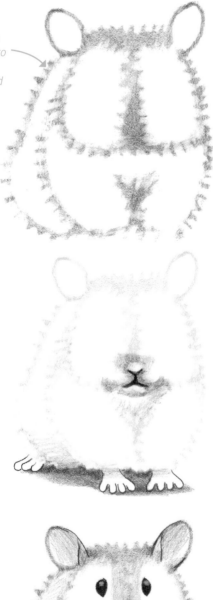

Shape the tip of a kneaded eraser into a point, and press it into the shading to leave small, pointed shaded areas in her fur.

3 Erase small U and V shapes in the thick body contours. This helps create the fluffy fur.

4 Erase the nose and chin shapes, and draw the nose, mouth, and paws. Shade the shadow under her body.

5 Add detail at the ears, draw the whiskers, shade the seedlike shape of the eyes, and erase a highlight in them.

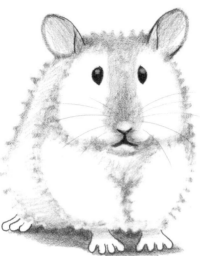

FUN FACT

Hamsters have poor eyesight and can find their way more easily by their sense of smell. They rub the scent glands located on their backs onto objects that will guide them.

gecko

Steps: 5

Difficulty: ● ○ ○ ○ ○

The spotted leopard gecko has wide-spread ridged toes that help him move over sandy surfaces. To make the gecko look like he's walking, in this drawing, the left arm and leg are stretched far apart and that side of the body is curved, while on the right side, they're closer and the body is straight.

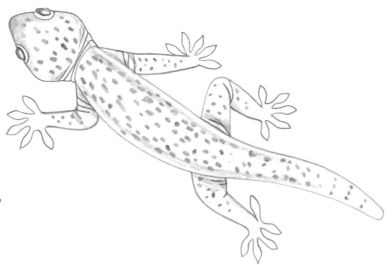

1 Sketch the long, curving contour of the body and tail.

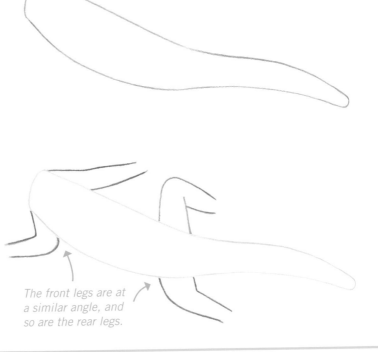

2 Draw the legs to angle in different ways. Make them narrower where the feet will attach.

The front legs are at a similar angle, and so are the rear legs.

3 Draw the toes stretched wide apart and round with pointed tips.

The stretched-out toes have a fanlike shape.

FUN FACT

Leopard geckos absorb the warmth of the sun (or a lightbulb), and store the heat in their bodies to maintain a healthy temperature while hunting and moving about at night.

4 Draw the head as a rounded triangle shape. Erase two sections to add the bulging eyes. Draw wrinkles at the neck.

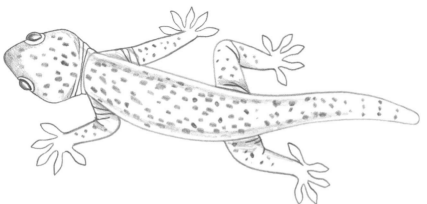

5 Add spots and more wrinkles on the legs. Shade the sides of the body; the tail, head, and eyes; and where the legs attach.

how to draw an iguana

Steps: 11
Difficulty: ● ○ ○ ○ ○

Iguanas are natives of the rocky and tropical geography of Central America and the Caribbean. Their skin has a range of scaly textures, and some can grow up to 4 feet long!

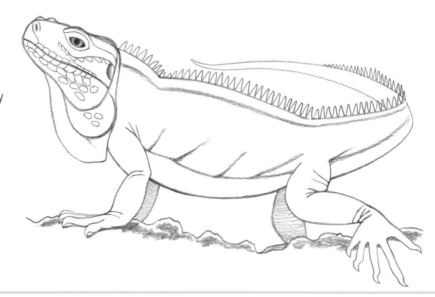

1 Draw the main shape of the head, and add an eye.

The angles of the lines are most important, so draw the shape carefully and don't include any sharp corners.

2 Draw the skin that hangs down from his neck (the *dewlap*).

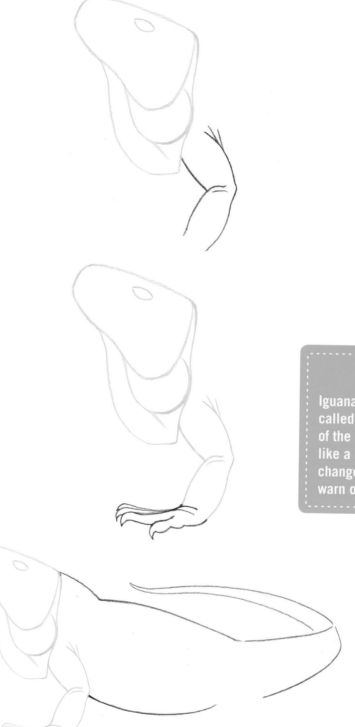

3 Add the front leg and then the wrinkles.

4 Draw the front foot.

FUN FACT

Iguanas have a light-sensing organ called a *parietal eye* on the top of the head. It doesn't have a lens like a normal eye, but it can sense changes in the light overhead to warn of potential predators.

5 Sketch the body and tail, leaving a gap for the rear leg.

6 Draw the rear leg and foot.

7 Add the nostril, mouth, ear (the *tympanum*), and the curves around the eye and on the top of the head. Shade the eye and ear.

ear →

8 Draw the pointed spines on the back, and make them gradually smaller as you work toward the end of the tail.

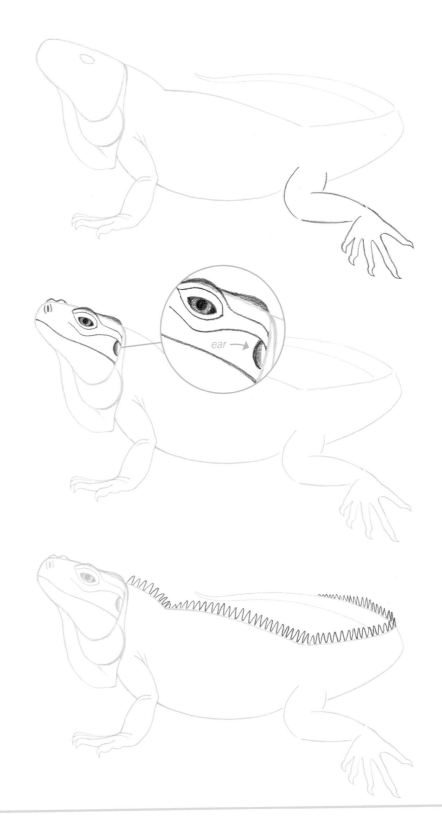

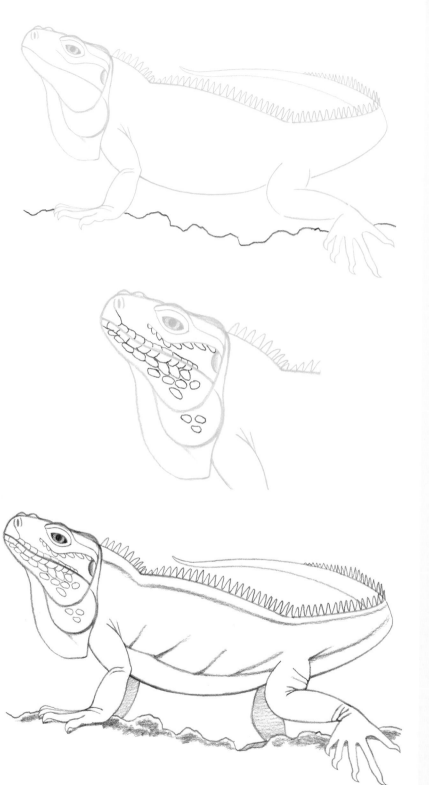

9 Add the outline of the rocky ground beneath the iguana.

10 With a sharp pencil, draw the skin texture around the mouth and the round scales.

11 Add shaded lines and wrinkles on the body, legs, and tail. Draw and shade the far legs, and shade the rocky ground.

finch

Steps: 5

Difficulty: ● ○ ○ ○ ○

The smooth look of this Gouldian finch is made with multiple gradations that darken at the edges of the body. Create the soft, white ring around the eye by shading up to it very carefully.

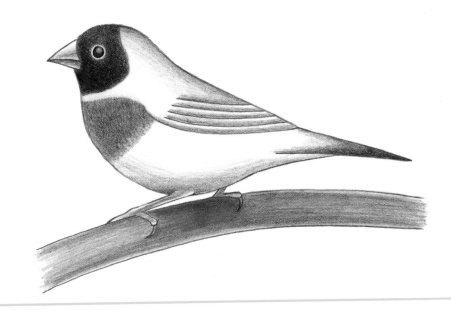

1 Draw the slightly curved lines of the beak. Shade the eye dark, and erase a highlight.

2 Draw the finch's main shape and wing with short, overlapping strokes. Leave a gap at the bottom for the leg.

Stroke away from the beak and out.

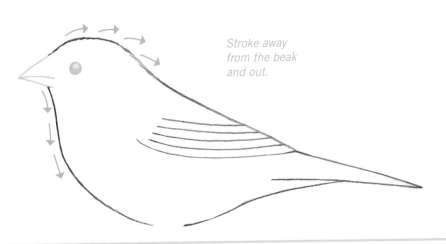

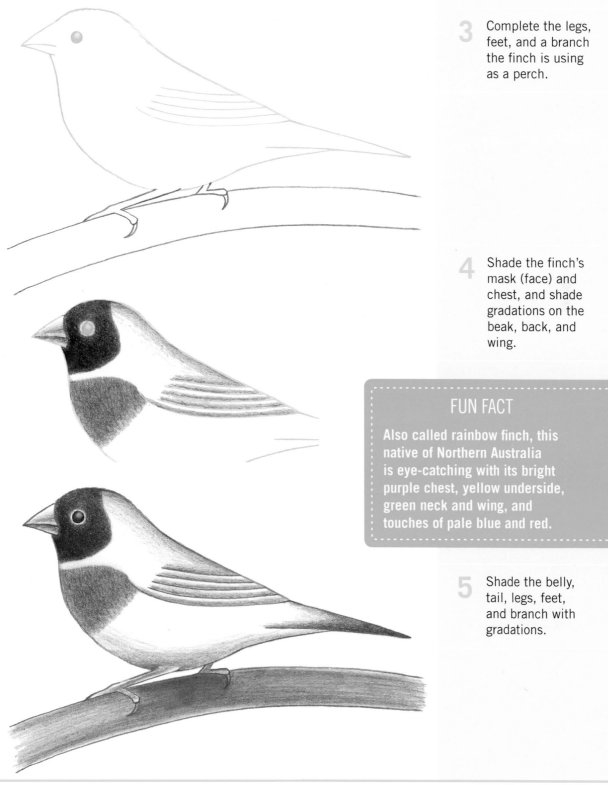

3 Complete the legs, feet, and a branch the finch is using as a perch.

4 Shade the finch's mask (face) and chest, and shade gradations on the beak, back, and wing.

FUN FACT

Also called rainbow finch, this native of Northern Australia is eye-catching with its bright purple chest, yellow underside, green neck and wing, and touches of pale blue and red.

5 Shade the belly, tail, legs, feet, and branch with gradations.

guinea pig

Steps: 11
Difficulty: ● ○ ○ ○ ○

Guinea pigs come in several breeds. This one is an Abyssinian, which has whorls in its fur called *rosettes*. Guinea pigs' faces can have humorous, almost human qualities.

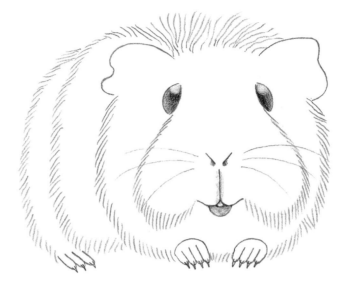

1 To make the eyes, draw two curves ³/₈ inch (1cm) tall and about 1 inch (2.5cm) apart.

2 Shade the eyes, and erase a high-light at the top of each.

3 Draw the nostrils and the mouth.

Draw the vertical line first to determine the center of the mouth and nose.

Angle the nostrils toward the bottom of the eyes.

4 Shade the nostrils and lips.

FUN FACT

Some guinea pigs, called *Peruvian guinea pigs*, have long, wiglike fur that drapes down their bodies.

Lightly sketch the cheek shape to create a guide before drawing the repeating lines if you want.

5 Draw repeating lines from the center of the face outward and down to create the furry cheeks.

6 Draw the wavy ears.

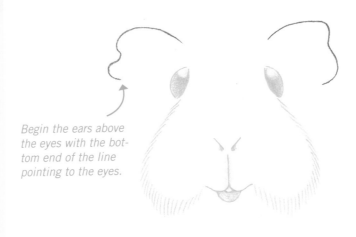

Begin the ears above the eyes with the bottom end of the line pointing to the eyes.

7 Draw the tops of the front paws.

8 Add the four toes and V-shape nails to complete the front paws.

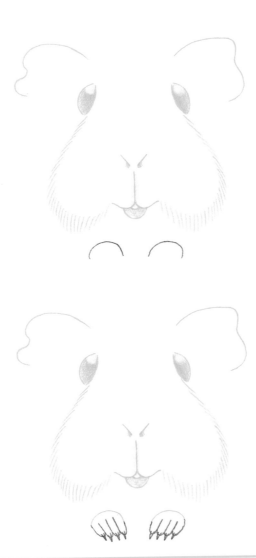

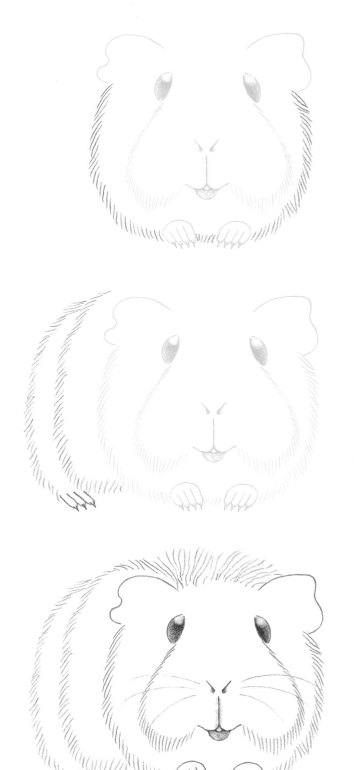

9 Draw repeating lines from the ears to the paws to develop the body's round shape.

10 Add two more curves of repeating lines and the three-toed rear paw to complete the side of the body.

11 Draw the longer, wavy hairs on the top of the head, and add the whiskers.

snake

Steps: 11

Difficulty: ● ○ ○ ○ ○

Snakes are popular pets. This king snake is a docile reptile that lays eggs and is not venomous. Its food, in captivity, is mice and small rats.

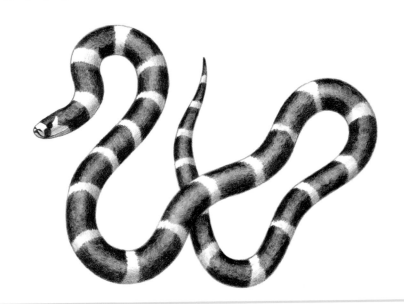

1 Sketch a curving line.

2 Draw the head to have a thumb-shape tip.

Stop before the end of the first line.

3 Sketch the edge of the snake's body, maintaining the same distance from the opposite edge so the snake's body is proportional.

4 Gradually draw the second line closer to the first as you work toward the narrower end.

5 Draw the tail beginning where the body overlaps.

FUN FACT

The king snake is also called a *chain snake* because of its chainlike bands of dark and light coloring.

6 Draw the mouth, and add a circle for the eye.

7 Draw the rectangular and triangular markings on the head. Shade them and the eye.

8 Draw curved lines across the snake's body, making every other line a bit farther apart. These will be the shaded sections.

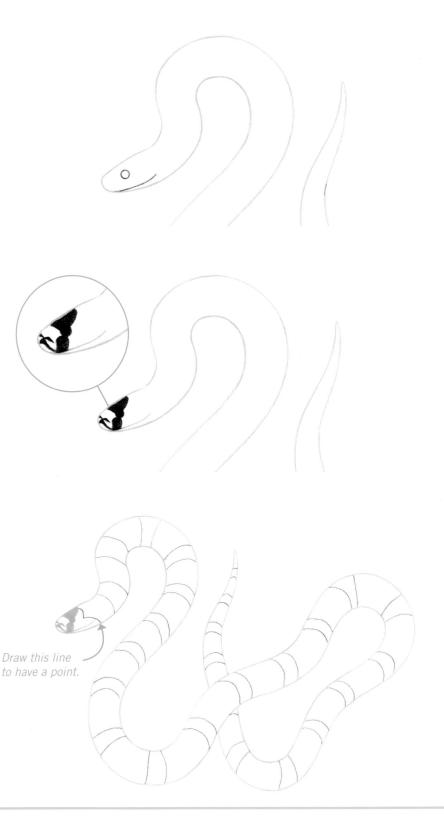

Draw this line to have a point.

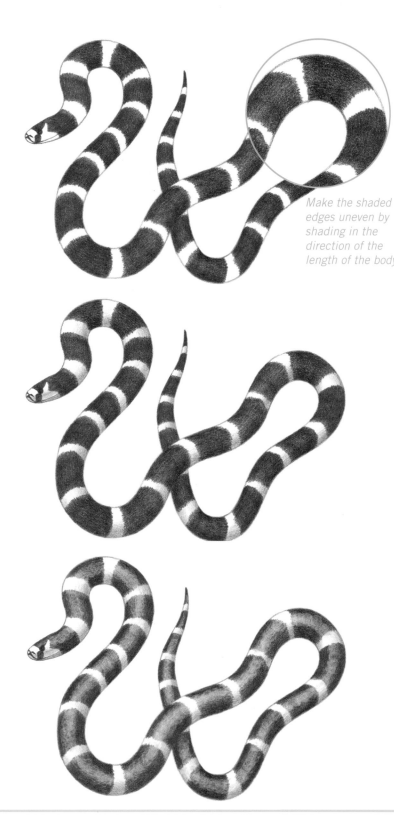

Make the shaded edges uneven by shading in the direction of the length of the body.

9 Shade the pointed section and then every other section, leaving unshaded white bands in between.

10 Shade the lower and right sides of the white sections to create the illusion of rounding.

11 Touch the rounded tip of a kneaded eraser to the center of the dark sections, creating a highlight. (Knead the eraser and reshape it into a small, round tip when the tip is covered with graphite.)



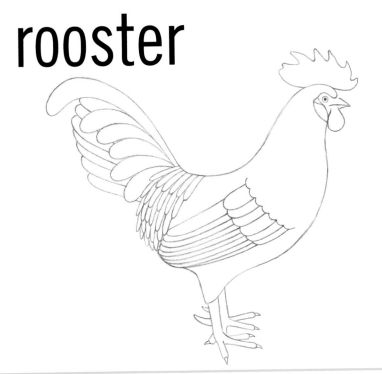

rooster

Steps: 11

Difficulty: ● ○ ○ ○ ○

The rooster is a male chicken and displays a variety of ornamental feathers. Like most bird species, the male is showier and a bit larger than the female.

1 Begin by drawing the beak and one eye.

Make the lines of the beak slightly curved.

2 Add the droplet-shape wattle below the beak.

3 Draw the triangular ear opening and the curved earlobe.

Draw the neck with repeating strokes that angle out slightly.

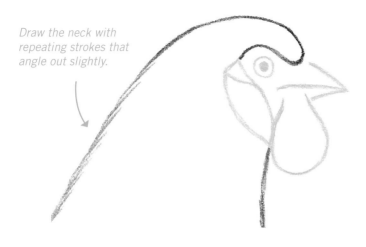

4 Draw the back down to where the tail will begin.

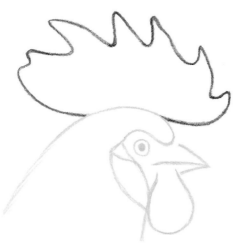

5 Draw the rooster's comb on top of his head.

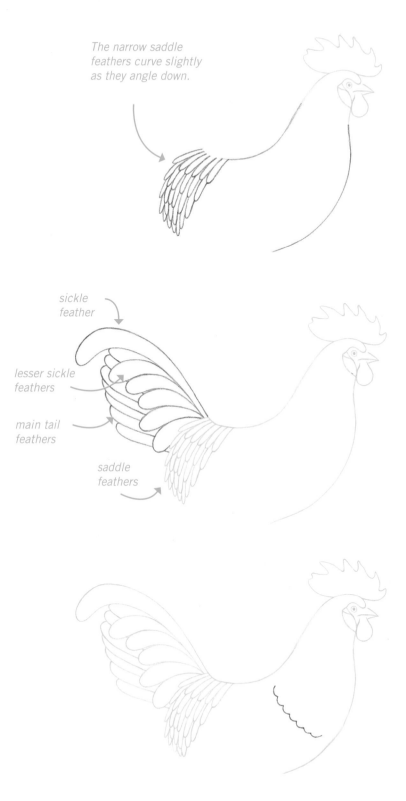

6 Continue the lines of the neck. At the end of the rooster's back, draw rows of long U shapes to create the saddle feathers.

The narrow saddle feathers curve slightly as they angle down.

7 Continue the line of the back, and draw the sickle feather, the lesser sickle feathers, and the main tail feathers.

sickle feather

lesser sickle feathers

main tail feathers

saddle feathers

8 Make the coverts of the wing by drawing a line of repeating curves.

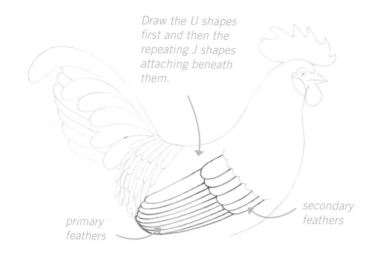

Draw the U shapes first and then the repeating J shapes attaching beneath them.

primary feathers

secondary feathers

9 Draw the secondary feathers followed by the longer primary feathers.

shank

spur

toe

nail

10 Complete the rooster's underside, and add the shank, toes, nails, and spur. Make the nails slightly curved.

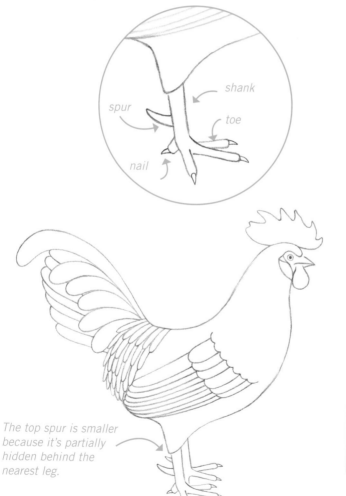

The top spur is smaller because it's partially hidden behind the nearest leg.

11 Add the shank, toes, nails, and spur of the far leg.

FUN FACT

The rooster's comb and wattle attract a hen's attention while the rooster does an up-and-down head bob called *tidbitting*. They also give an indication of the rooster's health.

chick

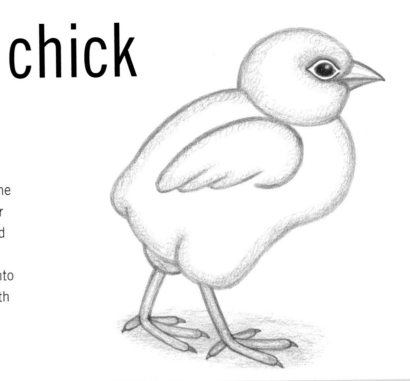

Steps: 11

Difficulty: ● ○ ○ ○ ○

Fluffy chicks grow into chickens. In this drawing, the chick's legs disappear under the feathers, angling forward and then back again. These zigzagging bones connect into the hips, which are level with the tip of the wing.

1 Rotate your paper 45 degrees to the left. For the chick's body, draw this unusual shape that looks like a cartoonish face.

The shape is taller than it is wide.

2 Rotate your paper back to straight, and draw the round and curling shape of the chick's head.

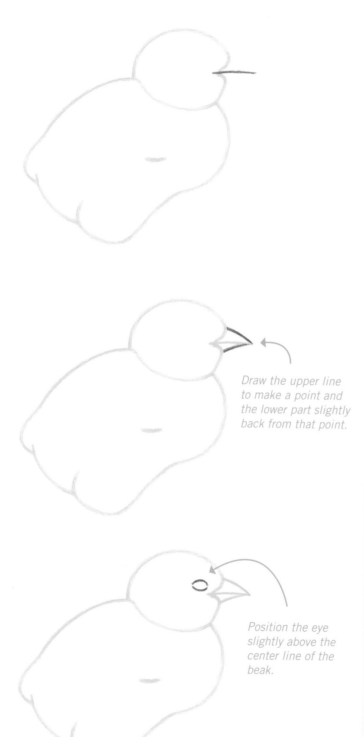

3 Draw a slightly curved line out from the curling parts of the head. This is the start of the beak.

4 Finish the beak by drawing the upper and lower curves.

Draw the upper line to make a point and the lower part slightly back from that point.

5 Make the upper and lower curves of the eye.

Position the eye slightly above the center line of the beak.

6 Draw a curving line around the eye, and shade in the pupil.

7 Continue the small interior mark from step 1, curling it up and back to make the wing. Add the wing feathers. Draw the legs, using pairs of lines that angle down.

The leg on the right ends lower than the one on the left.

8 Draw the feet and claws.

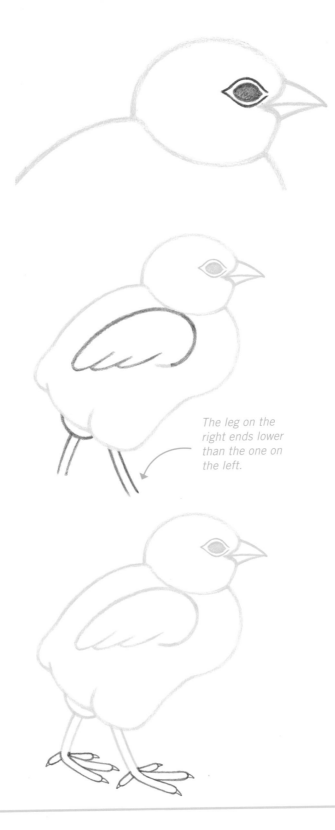

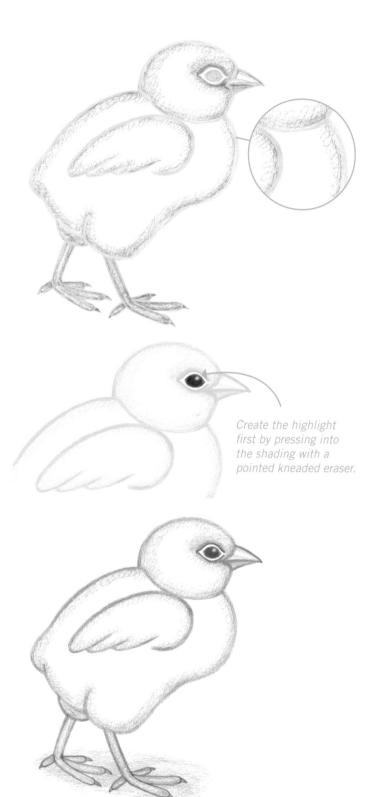

9 Shade the edges of the chick with soft, back-and-forth shading and looping.

10 Make a highlight in the eye with a kneaded eraser, and darken the rest of the eye.

Create the highlight first by pressing into the shading with a pointed kneaded eraser.

11 Shade a shadow around the feet with horizontal strokes.

parakeet

Steps: 11

Difficulty: ● ● ○ ○ ○

The parakeet's affectionate nickname, "budgie," is a shortened version of its species' scientific name, *budgerigar*. The variations of light and dark areas on the bird's shaded underside create the illusion of feathery softness.

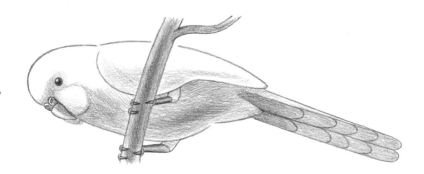

1 Lightly draw a triangle with vertical and horizontal sides both 1½ inches (3.75cm) long.

Keep this triangle light so it's easy to erase later.

2 Draw the curve of the parakeet's head and its eye within the triangle, and erase the triangle.

The small circle is near the center of the diagonal line and rests on top of it.

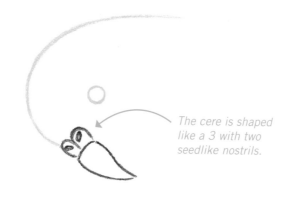

The cere is shaped like a 3 with two seedlike nostrils.

3 Draw the nostrils (the *cere*) and the beak.

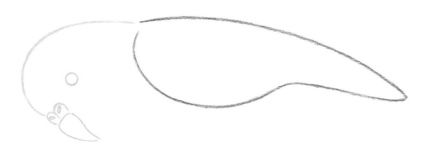

4 Draw the parakeet's wing.

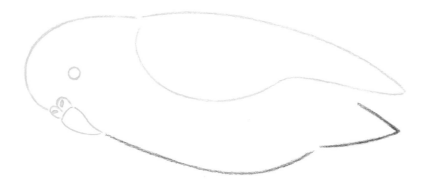

5 Draw the parakeet's underside with a curve and an angled V shape.

6 Make a straight line that begins at the tip of the V shape and extends out behind the parakeet. Make it a little shorter than the length of the wing.

7 Draw the tail with straight lines and curves on either side of the first straight line.

8 Add the interior curves of the tail feathers.

FUN FACT

Disco is a famous parakeet who can say nearly 100 funny phrases, snore, meow, beatbox, and more. He has appeared on national TV and has more than 120,000 likes on Facebook.

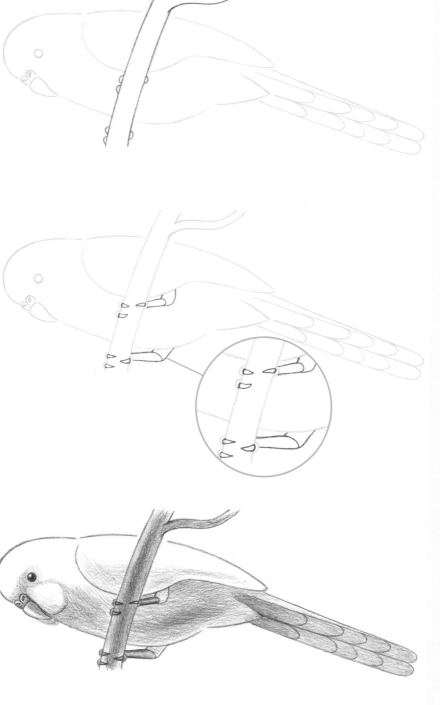

9 Erase sections of the middle of the bird, and draw a tree branch. Draw the toes around the branch using six small curves.

10 To the toes, add claws that are slightly curved. Then draw the parakeet's legs.

11 Shade the underside of the bird and the branch, leaving pale tones at the edges of the wing, belly, and branch and highlights on the eye, cere, beak, claws, and legs.

african gray parrot

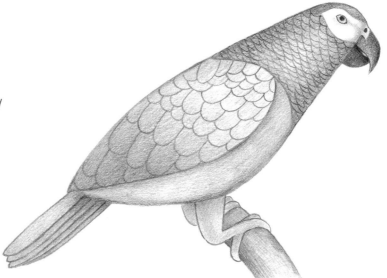

Steps: 11

Difficulty: ● ● ○ ○ ○

African rainforests are the natural habitat of this highly intelligent parrot. It has a black beak, a white mask, a gray body and wings, and bright red tail feathers.

1 Draw the parrot's neck, and copy the angles and curves shown here.

Lay your pencil along the edge of the example before you draw it. This helps you see the angle of the lines better and memorize them.

2 Draw the upper and lower parts of the parrot's beak.

The upper edge of the beak begins at the top of the angled line on the right.

The tip of the lower beak disappears inside the upper beak.

3 Draw the two curves of the eye, and make a small dot for the pupil.

4 Draw the long curves of the parrot's wing and the edge of the belly.

5 Draw three tail feathers that are about half the length of the wing.

6 Add two more feathers that tuck under the first three.

7 Add the leg. The toes are pointed because they'll wrap around a tree limb you'll draw in the next step.

8 Complete the parrot's other leg, and draw a tree limb grasped in his feet.

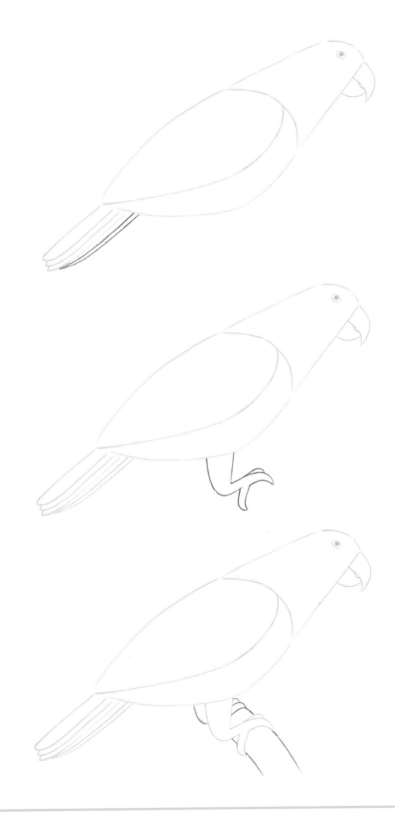

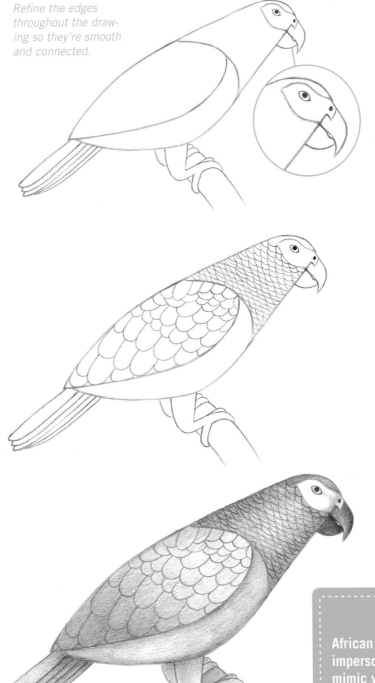

Refine the edges throughout the drawing so they're smooth and connected.

9 Erase a small part of the beak, and redraw the edge to have a beaklike point. Add the nostril as well as the curved mask around the eye.

10 Draw the repeating curves of the feathers of the parrot's neck and shoulder. Add the wing feathers.

11 Shade the parrot's beak, neck, wing, body, legs, and tail. Finally, shade the branch.

FUN FACT

African gray parrots are great impersonators. They can mimic voices and sounds, sing songs, and even repeat entire conversations.

chinchilla

Steps: 11

Difficulty: ● ● ○ ○ ○

Chinchillas, rodents native to the Andes Mountains in South America, are known for their very soft fur. They can suffer in the heat, so they regulate their body temperature by circulating blood to their prominent ears, where it can cool.

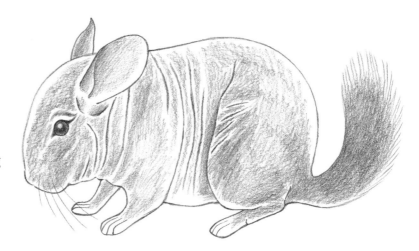

1 Begin by drawing the shape of the head in sections.

2 Draw the ears.

The far ear has a very different shape because it is seen from the side.

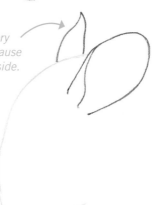

FUN FACT

In the wilds of Chile, chinchillas live in large groups called *herds* or *colonies*.

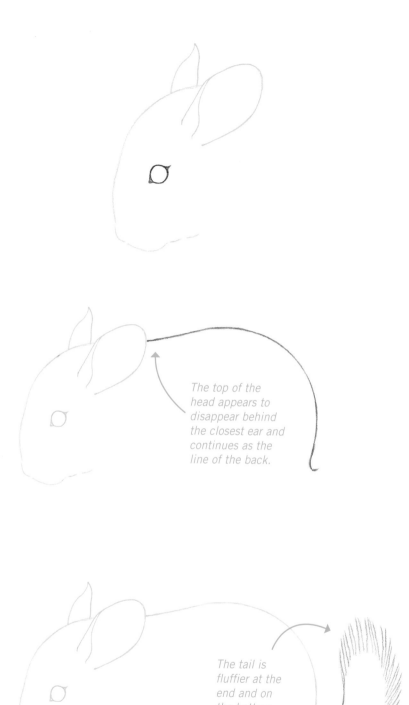

3 Draw a circle for the eye, and refine the shape by adding two pointed corners.

4 Draw the back down to where the tail will begin.

The top of the head appears to disappear behind the closest ear and continues as the line of the back.

5 Draw the tail with repeating short lines.

The tail is fluffier at the end and on the bottom.

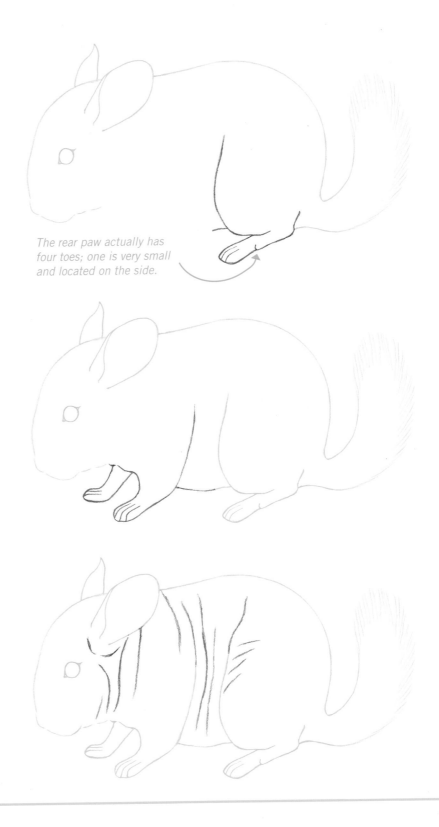

6 Draw the vertical lines of the leg and the outline of the back paw. Draw the curved lines separating the toes.

The rear paw actually has four toes; one is very small and located on the side.

7 Draw the belly and the front paws.

8 Draw the crevices of the plush fur with dark lines.

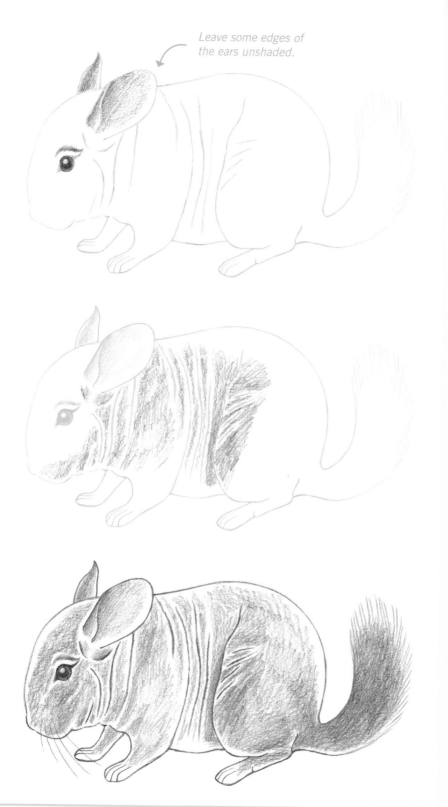

Leave some edges of the ears unshaded.

9 Shade the eye, and erase a highlight. Shade the ears and around the eye.

10 Shade around the crevices, leaving some white of the paper showing.

11 Shade most of the tail dark, complete shading across most of the body, and add whiskers.

persian cat

Steps: 11
Difficulty: ● ● ○ ○ ○

This Persian cat has striking features: fluffy fur, heavy brow, flat face (also called "*peke-faced*"), and round eyes. Silver Persian cats have white hairs tipped with black, creating a silver-gray coat. Their long fur requires plenty of combing and cleaning.

1 Draw the two outside curves of each eye; then draw the pupil and corner of each eye.

The lower lid curves up at the corner of the eye.

2 Draw the triangle of the nose, and add the interior details. Complete the downward-curving muzzle and lower lip.

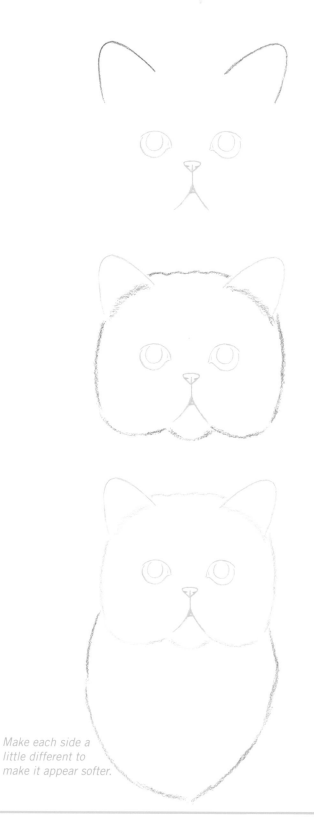

3 Add the ears. The inside of each ear edge begins above the pupil and is about the height of the distance from the nose to the bottom of the muzzle.

4 Sketch the main shape of the head, and shade at the base of the ears.

5 Add the shape of the fluffy chest.

FUN FACT

Persian cats are elegant and gentle. They were bred to have a flat muzzle and tiny nose.

Make each side a little different to make it appear softer.

6 Draw the cat's back and hind leg.

7 Sketch the underside with repeating angled strokes, and add the remaining three legs.

Make the lines of the front legs a bit wavy to make them look soft.

8 Draw the Persian's fluffy tail with long, curved, soft strokes.

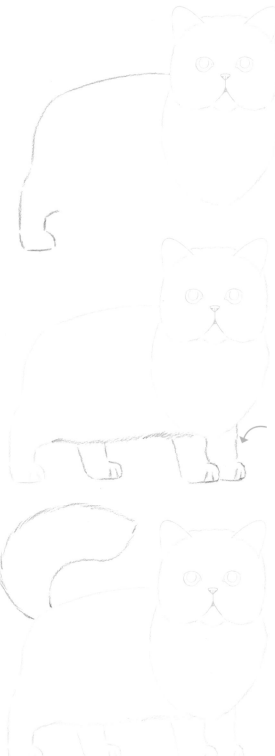

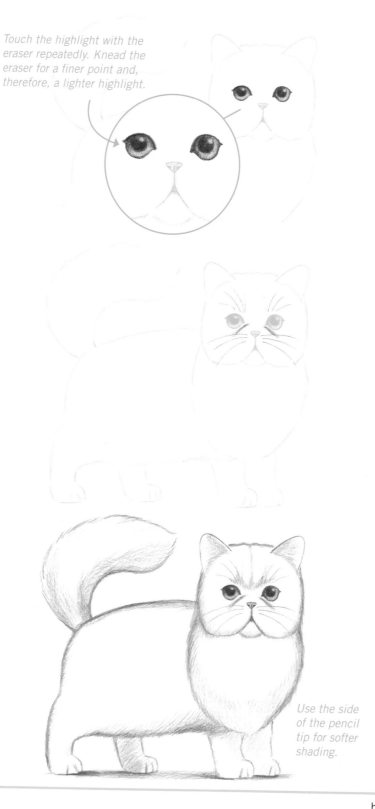

Touch the highlight with the eraser repeatedly. Knead the eraser for a finer point and, therefore, a lighter highlight.

Use the side of the pencil tip for softer shading.

9 Shade the pupil dark and the iris medium gray, and erase a highlight by touching the dark shading repeatedly with a pointed kneadable eraser.

10 Shade the upper muzzle lines below the eyes, and add the whiskers.

11 Add fluff to the fur by shading softly at the main edges and at the forehead, ears, and tail. Shade a shadow below.

how to draw a yorkshire terrier

Steps: 11

Difficulty: ● ● ○ ○ ○

Centuries ago, these feisty little dogs were employed to hunt rats in textile mills. Draw the coat with the side of your pencil, and make your marks close together to create its soft and silky texture.

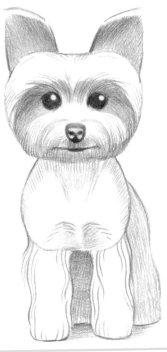

1 Draw two interlocking heart shapes, each as tall as they are wide, and the lower one a bit smaller than the top one.

Draw these shapes lightly using broken lines.

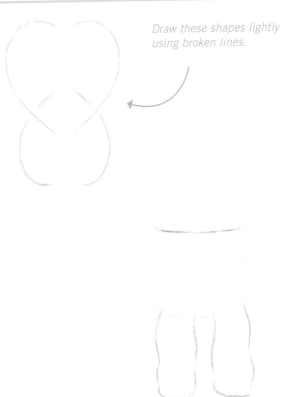

2 Draw a slightly curved line just above where the hearts intersect; this will be the Yorkie's chin. Then draw the two front legs using wavy lines.

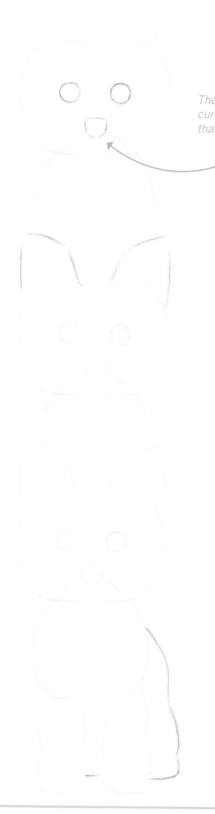

The nose has a broad, curved top and sides that angle in.

3 Erase the bottom point of the upper heart, below the slightly curved line added in step 2. Then add the nose shape at the top edge of the lower heart shape and two circles for the eyes.

4 Sketch the ears using broken lines.

5 Add the rear leg of the seated dog and a small line between the front legs.

FUN FACT

Nicknamed "Yorkies," these terriers have a golden and blue-gray coat that grows long enough to hang to the floor unless it's trimmed. They're considered a toy breed because of their tiny size.

6 Shade the eyes and nose, and erase highlights with a kneadable rubber eraser.

The wide highlight on the nose has a triangular point in the middle, and the two smaller ones for the nostrils angle up.

7 Shade the mouth, and pencil in the muzzle fur.

Make the muzzle fur dark enough to cover the upper two angled lines of the lower heart shape.

8 Shade the fur around the Yorkie's eyes with strokes that angle up, out, and down.

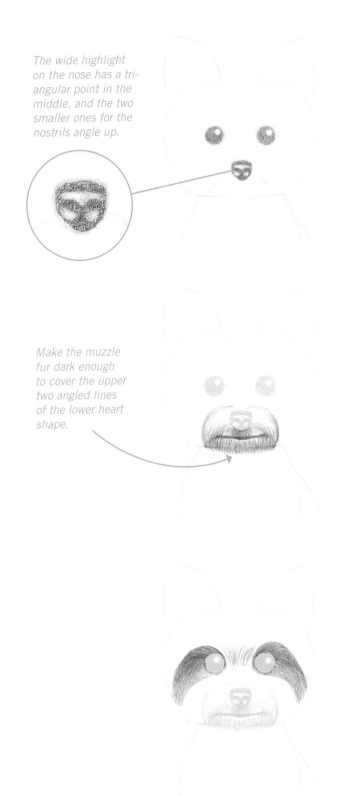

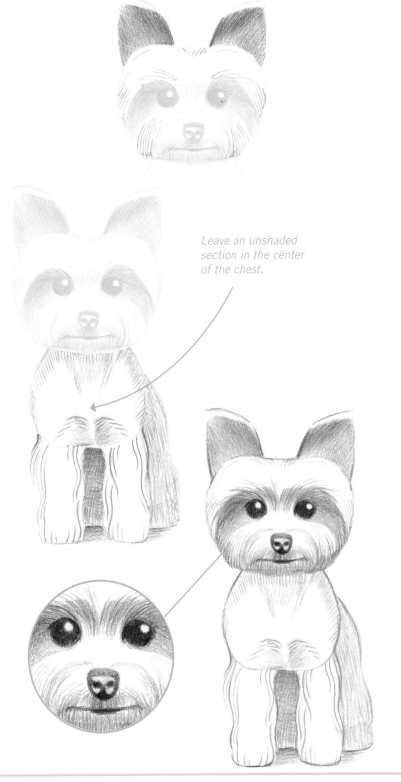

Leave an unshaded section in the center of the chest.

9 Shade the ears with strokes that angle up and out; then refine the fur of the face.

10 Shade the body with straight, curved, and wavy lines. Add the shadow below.

11 Darken the shading of the eyes, lower nose, mouth, and main edges.

cocker spaniel

Steps: 11

Difficulty: ● ● ○ ○ ○

Cocker Spaniels have thick, wavy, curly hair that grows from their ears, legs, chest, and underside. They make great show and sporting dogs and are gentle family pets.

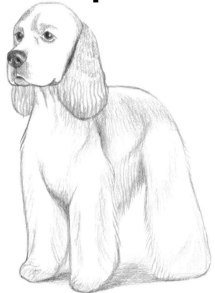

1 Lightly sketch a square with 2-inch (5cm) sides.

Make the square very light so you can erase it easily later.

2 Draw the main shape of the dog's head inside the box.

The left eye is less wide than the right eye because its eyelids are at a different angle.

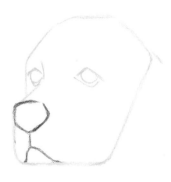

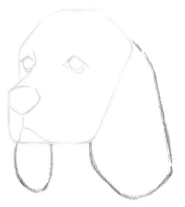

3 Erase the square drawn in step 1. Draw the dog's eyes using slightly curved L shapes and semicircles.

4 Draw the nose and mouth.

5 Sketch the ears.

FUN FACT

The long hair that hangs from the Cocker Spaniel's body is called *feathering*. It's not a coincidence this breed is a great bird-hunting dog.

6 Refine the over-hanging side of the mouth (the flew) and the neck, and draw the front legs.

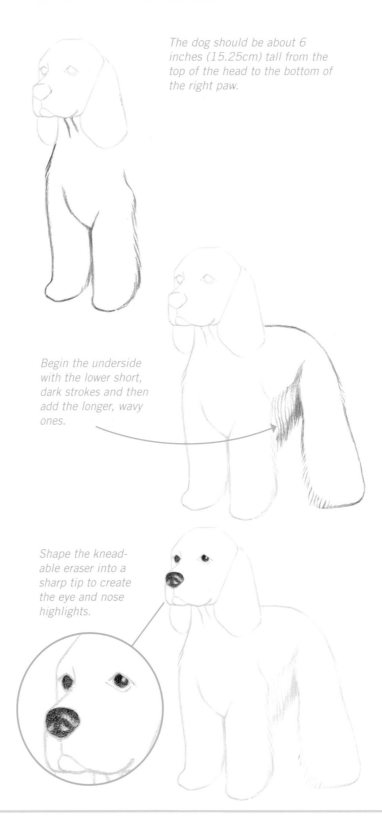

The dog should be about 6 inches (15.25cm) tall from the top of the head to the bottom of the right paw.

7 Draw the dog's underside and rear leg using soft, wavy lines.

Begin the underside with the lower short, dark strokes and then add the longer, wavy ones.

8 Shade the eyes and nose. Erase a highlight from the right eye and three from the nose.

Shape the knead-able eraser into a sharp tip to create the eye and nose highlights.

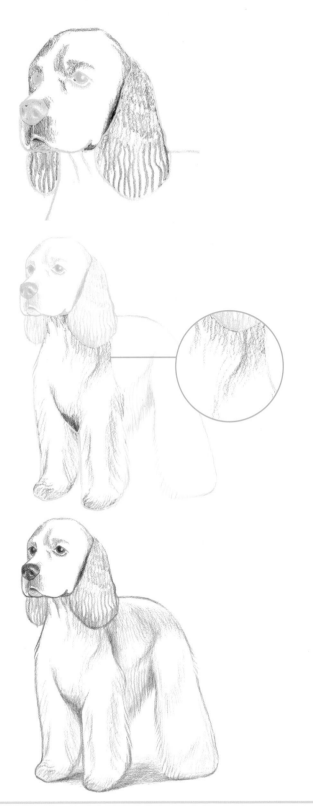

9 Shade parts of the head, around the eyes and mouth, and the ears.

10 Shade the Cocker Spaniel's chest and front legs with soft wavy and curved lines.

11 Darken the eyes and nostrils, shade the back part of the dog, and add the shadow below.

german shepherd dog

Steps: 11
Difficulty: ● ● ○ ○ ○

Today a popular pet, the German Shepherd Dog was originally bred to herd sheep. The breed has been invaluable to the military, to police, and in health-care settings as a therapy dog assisting the disabled.

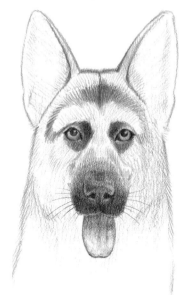

1 Draw a horizontal line about 1 inch (2.5cm) long. Then draw two more pairs of angled lines.

Sketch these lines softly with the side of your pencil's tip.

2 Draw the German Shepherd's ears.

Make the longest side of the ear the same length as the long section of the head (3 inches/7.5cm).

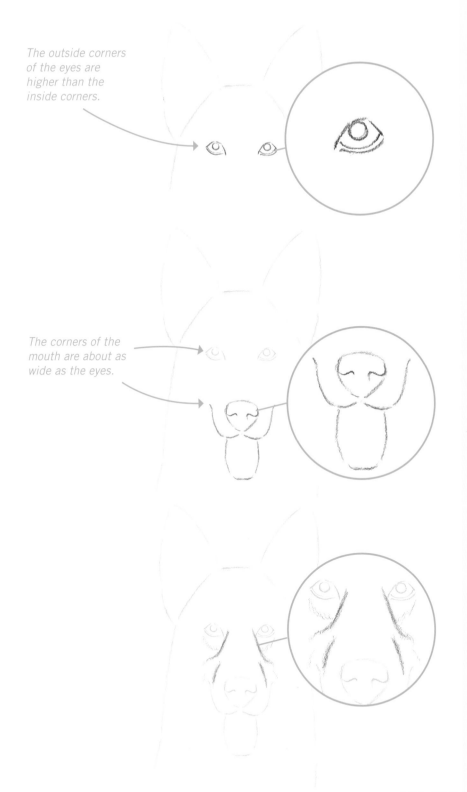

The outside corners of the eyes are higher than the inside corners.

The corners of the mouth are about as wide as the eyes.

3 Draw the three angled lines of the top lids, add the lower curves, and pencil in small circles for the pupils.

4 Draw the nose and nostrils, and add the mouth and tongue. The nostril is one ear length (3 inches/7.5cm) from the top of the head.

5 Shade the lines of the muzzle and under the eyes.

6 Shade the ears and top of the head, and add fur texture.

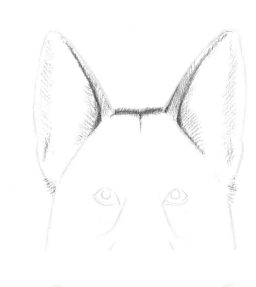

7 Shade the eyes and the markings on the forehead.

Change the angle of your strokes to follow the pattern of the fur.

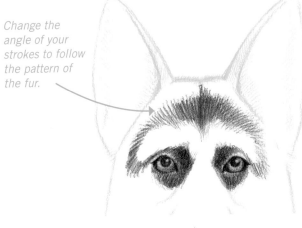

8 Shade the fur of the muzzle and the sides of the face.

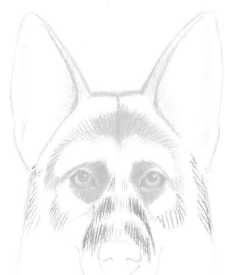

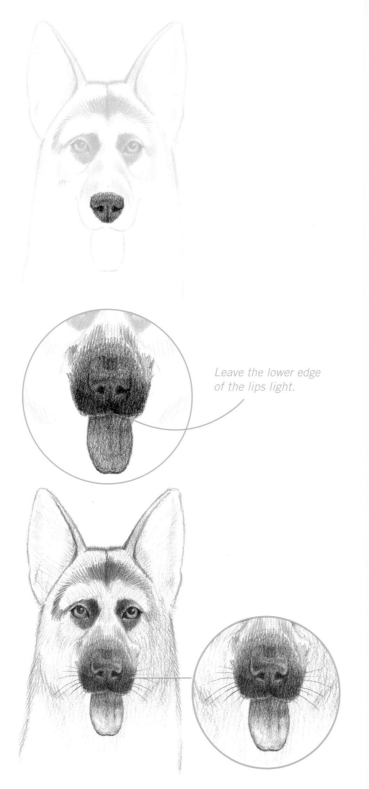

9 Shade the nose, and color the nostrils and the vertical line between the nostrils darker.

10 Shade the dog's muzzle and tongue.

Leave the lower edge of the lips light.

11 Add texture to the neck, and erase highlights on the nose and tongue using a kneaded eraser. Finally, add light fur texture and some whiskers.

dalmatian

Steps: 10
Difficulty: ● ● ○ ○ ○

The coat of this popular pooch can have a wide range of spot patterns. Group the spots in your drawing differently but in clumps with areas of white space in between for a more natural look.

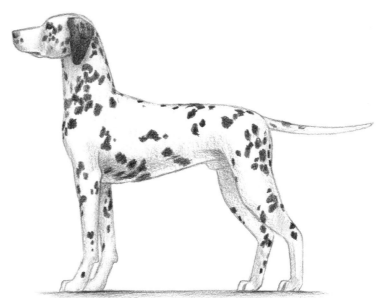

1 Draw a light rect-angular box 5⅜ by 7⅛ inches (13.5 by 18cm). Mark the box every 1¾ inches (4.5cm), and divide the box into 12 squares.

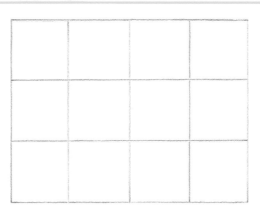

2 Use the grid to draw the Dalma-tian's body. The box lines help you make each part the correct size.

First draw the head in the top half of the square in the upper-left corner.

After the head, draw the main body in the center of the large rectangle.

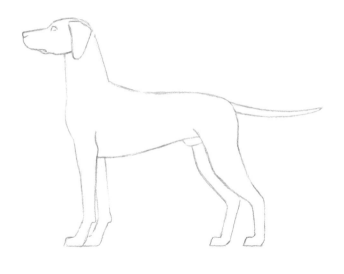

3 Erase the box and marks, smooth the edges of the dog's body, and add the contours of the ear and face.

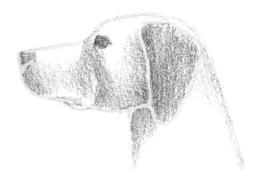

4 Shade areas of the face with soft edges.

Clean the eraser after every fifth tap or so by pulling it. Then reshape it.

5 Erase into the shaded areas by tapping the tip of a shaped kneaded eraser into those areas of your paper.

6 Shade the body.

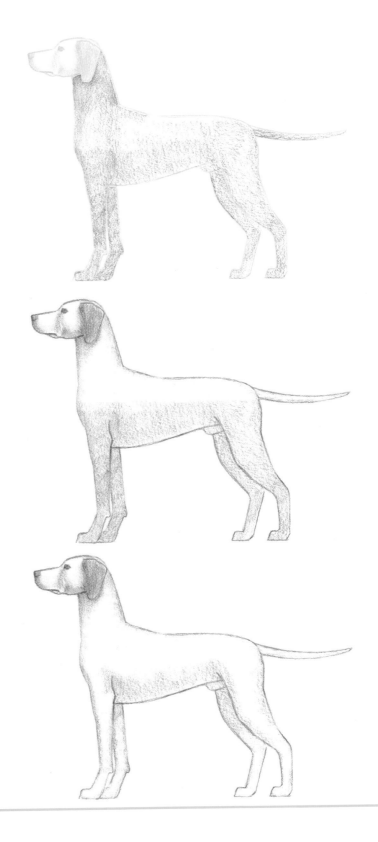

7 Press a kneaded eraser onto your paper to lighten parts of the dog's upper-body shading.

8 Refine the shading of the lower body and the legs with your eraser.

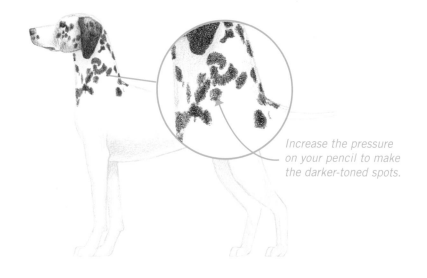

Increase the pressure on your pencil to make the darker-toned spots.

9 Refine the shading of the head, and draw irregular spots that become flatter and lighter at the edges of the dog's body.

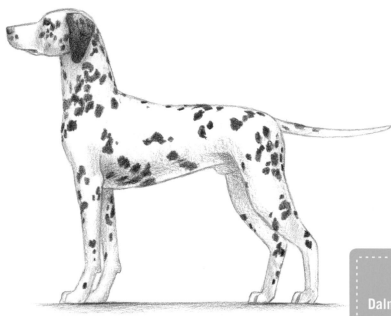

10 Continue making loose groups of spots across the body. Refine the paws, and complete the spots on the legs. Shade the ground.

FUN FACT

Dalmatians were once used to defend the horses pulling carriages and fire trucks before vehicles had engines. Even in ancient times, the breed was famous for its speed, bravery, and fierce strength, as well as its spots.

how to draw a beagle

Steps: 11

Difficulty: ● ● ○ ○ ○

This dog looks small and sturdy because the head and feet are larger in relation to the body and legs. Create depth and softness in the fur texture with lighter shading at the edge of the dark areas.

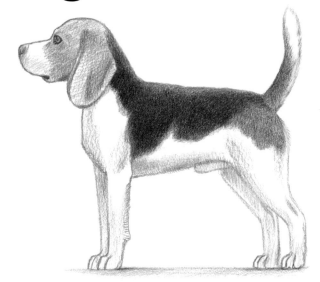

1 Draw a light box 5⅛ by 6¼ inches (13 by 16cm), and sketch the edges of the dog's body in sections. Draw the head and back first, followed by the chest and front legs, underside, tail, and rear legs.

Compare the negative spaces of your drawing with the illustration to see if they're similarly shaped.

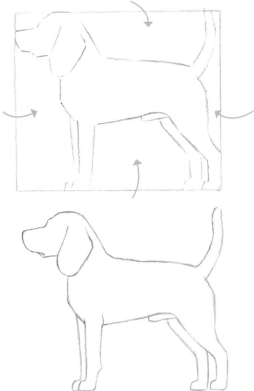

2 Erase the box, and smooth the edges of the beagle's body.

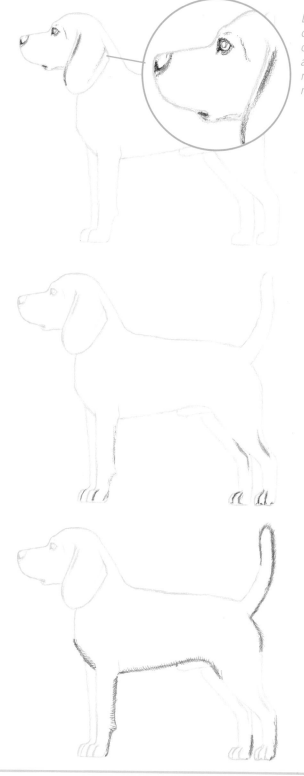

Draw the darker details like the corner of the eye and the pupil, the nostril, and the mouth last.

3 Draw the soft shapes of the nose, eye, ear, and mouth, and add the darker, more defined details.

FUN FACT

Beagles have very sensitive noses and are used to sniff luggage at airports for illegal substances.

4 Refine the details of the paws and hind legs.

5 Draw the fur texture on the edges of the tail, chest, belly, and legs.

6 Shade areas of the head and body.

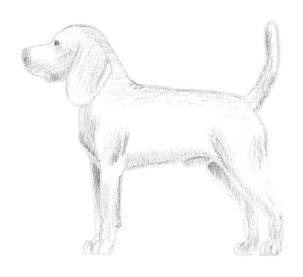

7 Shade the darker tones of the head and neck.

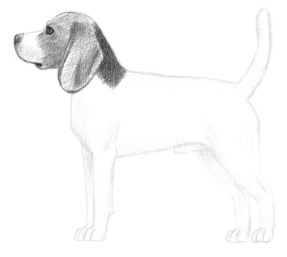

8 Shade the dark area across the back and at the base of the tail.

Leave this area lighter for a rounded look.

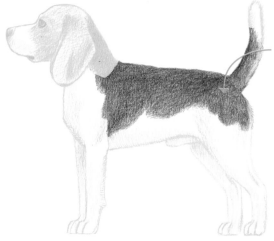

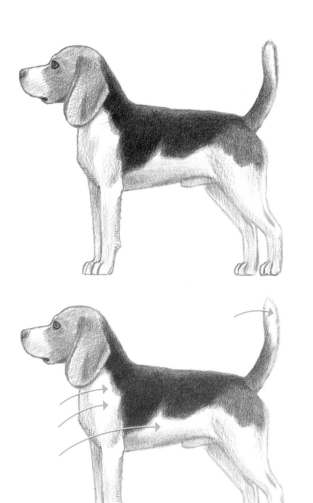

9 Intensify the dark shading on the back slightly away from the edge and down.

10 Lighten and refine the edges of the white areas of fur with a pointed kneaded eraser.

11 Shade the shadow cast on the ground below the beagle with horizontal and angled lines.

blue tang fish

Steps: 5

Difficulty: ● ● ● ○ ○

This tropical fish, which you might recognize from a Disney animated film, has unique stripes at the mouth and tail. Create the darkest shading of the face in two dark layers, and tone the body with side-to-side strokes so it's darker at the edges.

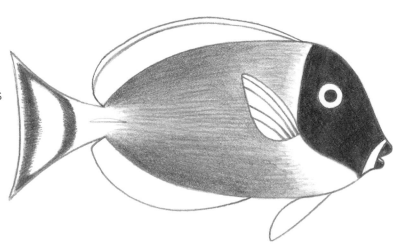

1 Draw a cup shape with a triangular base.

2 Turn your paper to the right, and draw the fish's face at the open end of the cup.

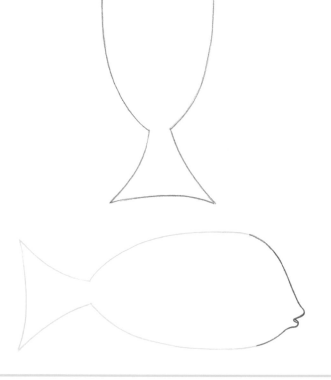

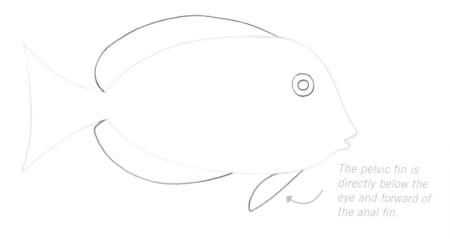

3 Add the top dorsal fin, the pelvic fin, the bottom anal fin, and an eye.

The pelvic fin is directly below the eye and forward of the anal fin.

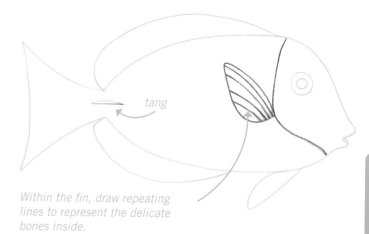

tang

Within the fin, draw repeating lines to represent the delicate bones inside.

4 Draw the lines of the face and the pectoral, or side, fin. Draw the thin tang blade at the base of the tail.

FUN FACT

The blue tang fish—also called blue doctor, blue barber, and surgeonfish—gets its name from the razor-sharp spines, or tangs, on either side of the base of its tail.

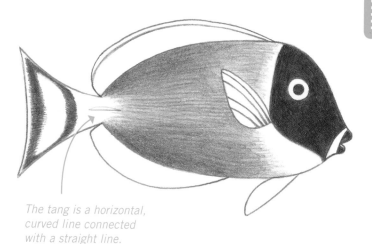

The tang is a horizontal, curved line connected with a straight line.

5 Shade the D shape in the tail, the body, and the face. Add a line on the dorsal fin.

hermit crab

Steps: 11

Difficulty: ● ● ● ○ ○

To create the hermit crab, you'll draw different sizes and shapes of tube sections. Then you'll shade the crab darker where the leg sections attach and lighter at the sides to make it look round.

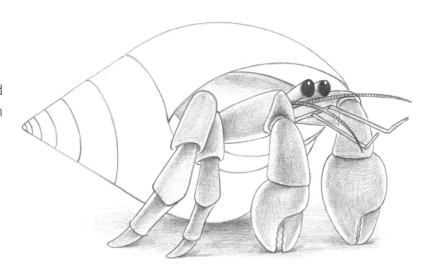

1 Draw a V that opens to the right.

2 Add curving lines that stretch across the V and then add two longer ones that curve to the right and form a point.

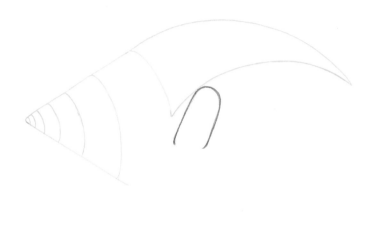

3 For the upper leg section, draw an upside-down U shape with curved ends.

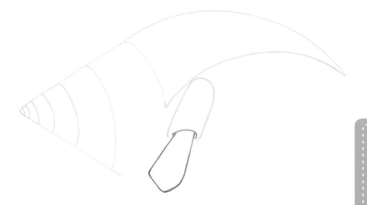

4 Draw a curved opening, followed by the second leg section.

FUN FACT

Hermit crabs can communicate with clicking, chirping, or croaking noises.

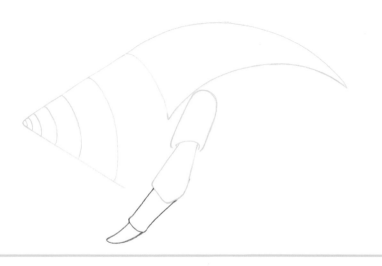

5 Complete the leg with a narrow section and a curved V shape.

6 Add another leg that is overlapped by the first one.

7 Draw two of the foreleg sections using curved lines.

8 Draw the pincer, including its curved tips and wavy inside edges.

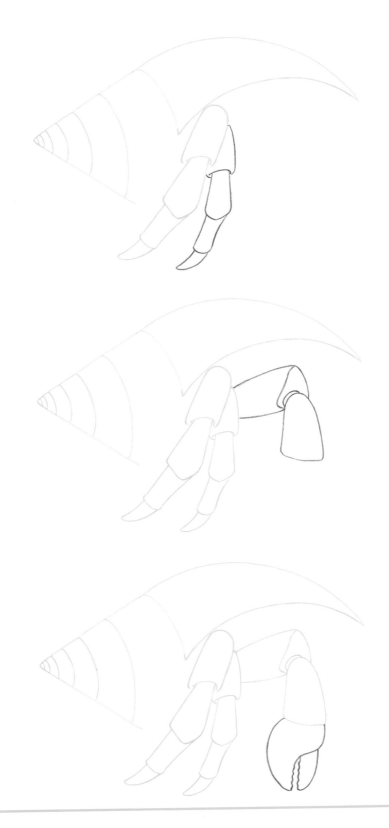

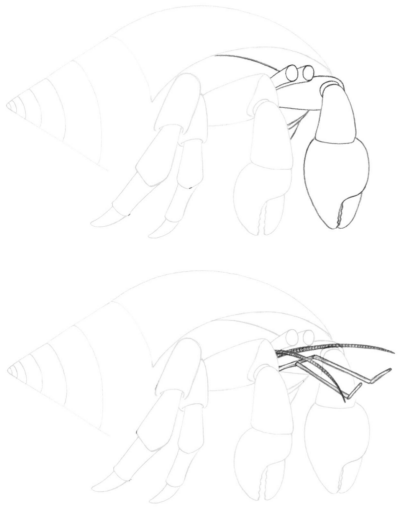

9 For the eyes, draw ovals with curved sides. Next, draw the largest arm with a bigger pincer.

10 To add the antennae, pencil in long double curves with curved stripes. The antennules, or smaller antennae, are each made of three thin sections.

Leave nonshaded spaces at the edges of the crab sections to create a reflected light effect.

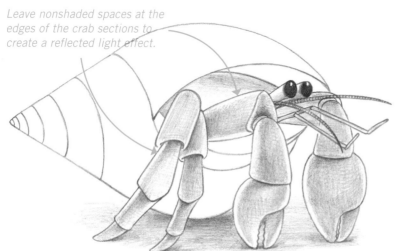

11 Complete the shell around the crab's body and then shade the body section by section with down strokes as well as side-to-side ones. Add a shadow under the crab.

how to draw a clown fish

Steps: 11

Difficulty: ● ● ● ○ ○

The clown fish's body is patterned with wavy vertical stripes. When you draw it, use changing tones and curved lines at the edge of the fish's body to create the illusion it's rounded.

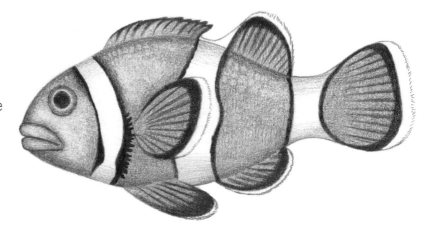

1 Draw the shapes of the face and eye.

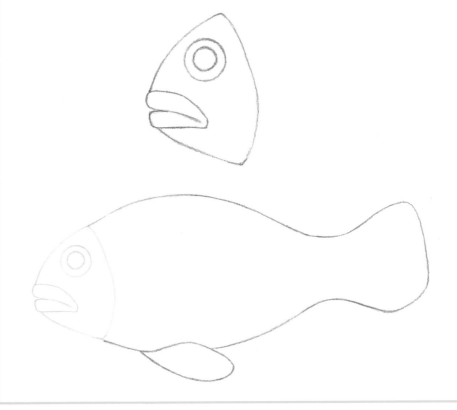

2 Draw the wavy edge of the fish's body and its ventral, or bottom, fin.

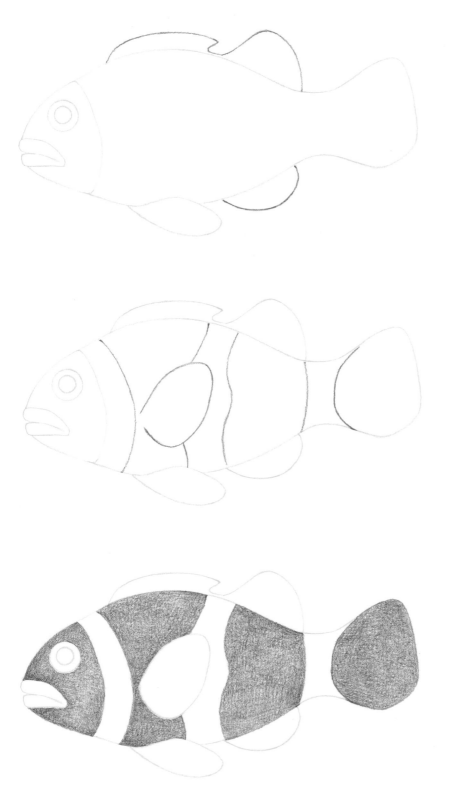

3 Add the dorsal fin on the top side and the anal fin on the bottom side.

4 Draw the outlines of the pectoral fin and the curved and wavy stripes.

5 Shade the four striped sections with vertical shading. Go back over this area with horizontal shading to even out the tone.

6 Shade the mouth, eye, and fins.

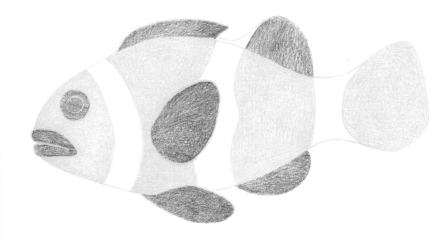

7 Shade the edges of the body darker.

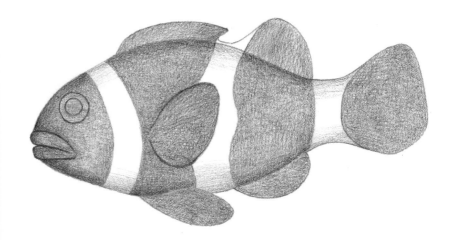

8 Shade the darkest edges of the stripes, eye, and fins.

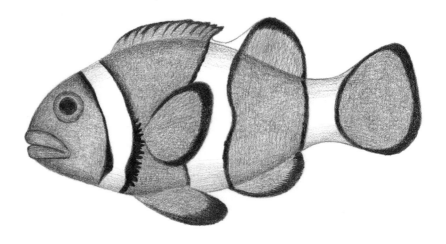

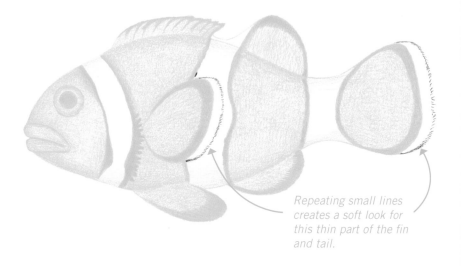

9 Use a sharp pencil to draw the outermost edges of the pectoral fin and tail with small strokes.

Repeating small lines creates a soft look for this thin part of the fin and tail.

10 Make a point on a kneaded eraser, and create a ring around the eye's pupil with little touches of the eraser to the paper.

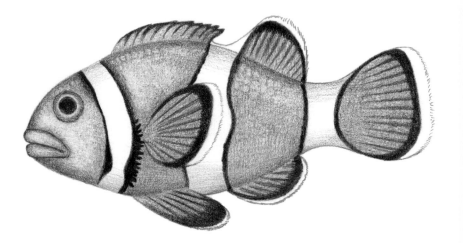

11 Add lines to the fins. Round the tip of your eraser, and press it repeatedly in a curving pattern across the fish's upper body. Pull apart your eraser and re-shape it frequently.

betta fish

Steps: 11

Difficulty: ● ● ● ○ ○

Betta fish are aggressive but have graceful, flowing fins and tails. For smoother curves as you draw, rotate your paper occasionally and allow your wrist to bend.

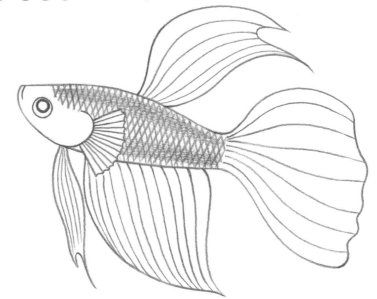

1 Draw the straight top line of the betta's body that gradually curves downward. Then draw the lower curved and curling line.

Be careful not to make the tip of the fish a sharp point.

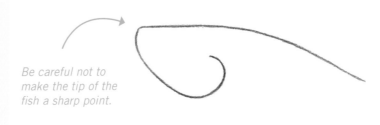

2 Draw the mouth and eye, and make lines radiating from the curled part.

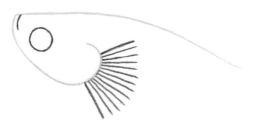

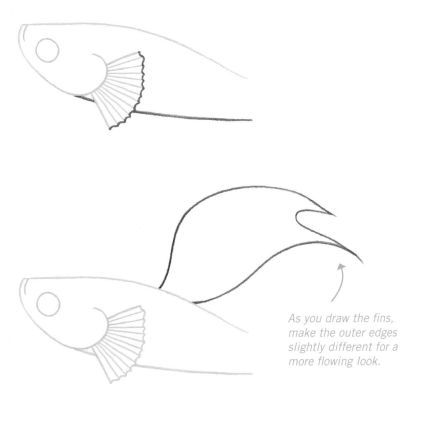

3 Draw curves that connect the radiating lines you drew in step 2. Draw the underside of the fish.

4 Make the curved upper and lower edges of the top dorsal fin and then draw the curved connecting line.

As you draw the fins, make the outer edges slightly different for a more flowing look.

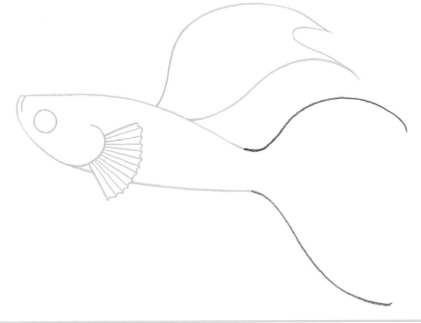

5 Draw the outer curves of the tail.

6 Connect the two curves of the tail with a wavy line.

7 Add the bottom-front ventral fin at the curling gill. Then draw the larger anal fin a bit farther back along the fish's underside.

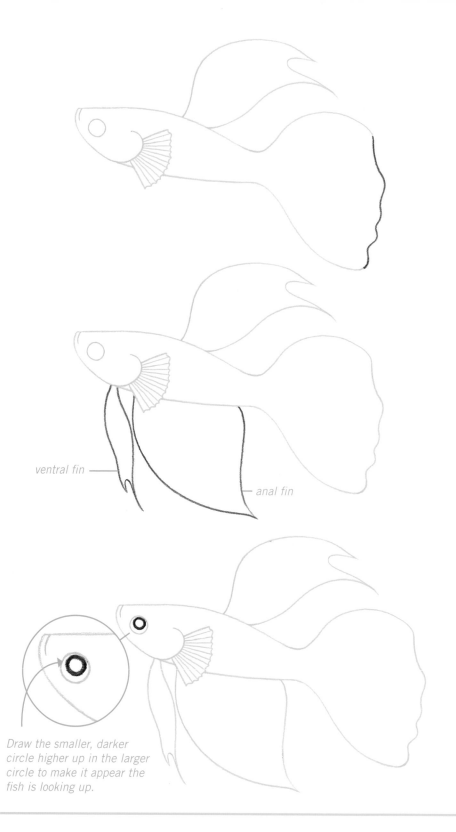

ventral fin ———

——— anal fin

8 Make a dark circle in the interior of the eye.

Draw the smaller, darker circle higher up in the larger circle to make it appear the fish is looking up.

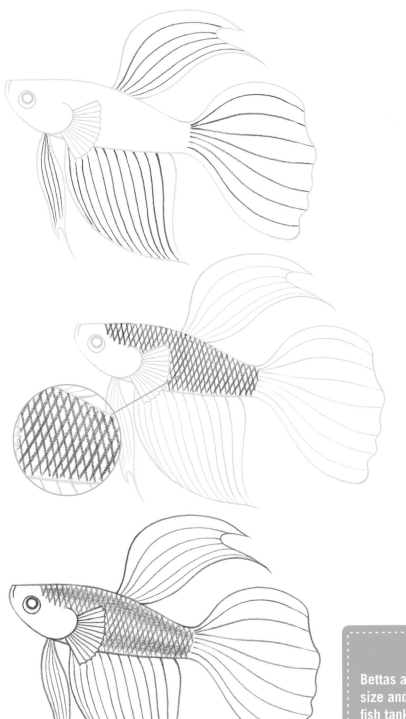

9 Draw curving lines in the fins and tail.

10 Draw straight lines on the fish's side that angle down to the right, followed by lines that cross the first set, angling down to the left.

11 Shade over the scales, making two soft stripes.

FUN FACT

Bettas are strong for fish of their size and can jump out of an open fish tank.

goldfish

Steps: 11
Difficulty: ● ● ● ○ ○

The goldfish is the classic childhood pet. When drawing this goggle-eyed bowl dweller, angle the curved lines of the scales carefully to create the rounding effect.

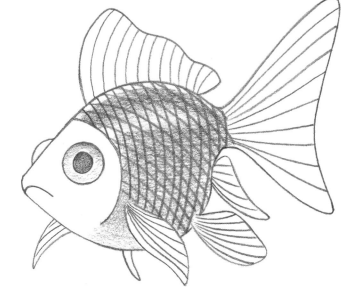

1 Draw a line that angles up, curves down, and angles up again.

2 Round the end of the line and then bend it downward for the tail.

The line's left end, near the nose, is a little lower than its right end, at the tail.

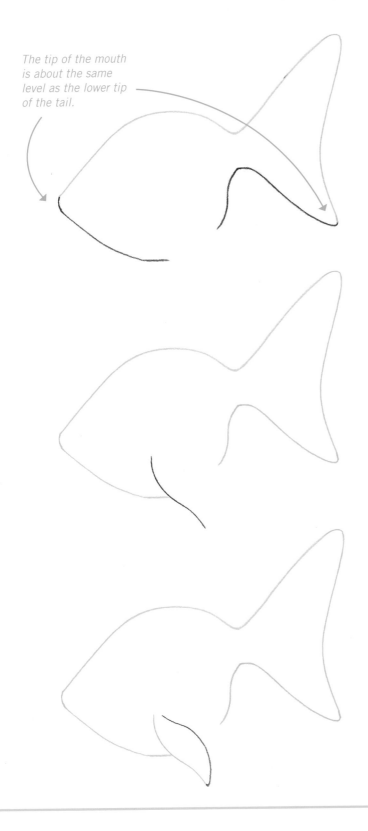

The tip of the mouth is about the same level as the lower tip of the tail.

3 Complete the tail, and draw most of the rest of the goldfish's body, starting below the mouth. Leave a gap on the underside to add fins.

4 Draw a curved line to begin the pectoral fin.

5 Complete the fin with another curve, leaving a small gap at the top.

6 Draw the remaining fins and the goldfish's belly.

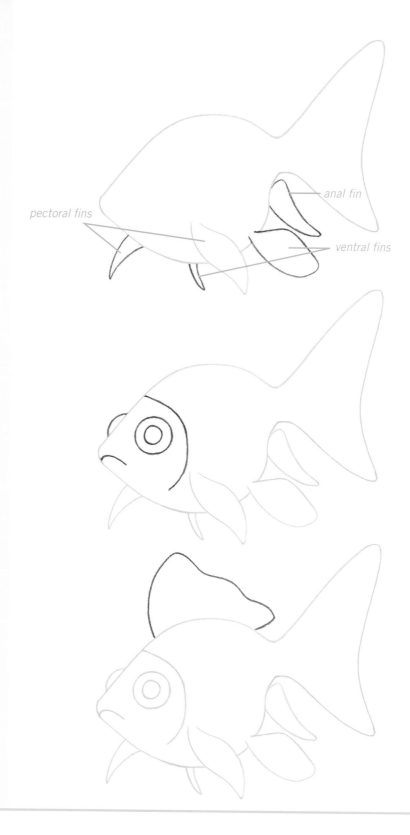

pectoral fins

anal fin

ventral fins

7 Add the mouth, the eyes, and a curved line to define the face.

8 Draw the dorsal, or top, fin.

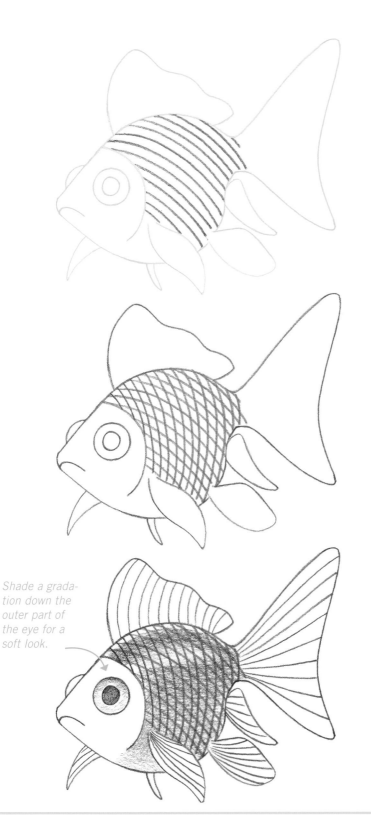

Shade a gradation down the outer part of the eye for a soft look.

9 Begin the scales with lines that curve downward to the right.

10 Cross the lines you drew in step 9 with ones that curve downward to the left.

11 Shade the eye and body, leaving highlights. Draw lines in the fins and tail.

pony

Steps: 11
Difficulty: ● ● ● ○ ○

Ponies are small, sturdy horses. They look more solid and stocky next to larger breeds of horses.

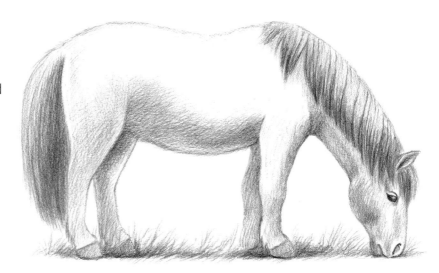

1 Draw a light square divided in half horizontally.

2 Use the box to help you know where to draw the outline of the pony's body.

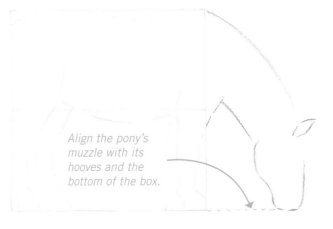

Align the pony's muzzle with its hooves and the bottom of the box.

3 Lightly draw a dashed line extending horizontally from the box's lower-right corner so you know where to place the pony's muzzle and then draw the pony's head and neck.

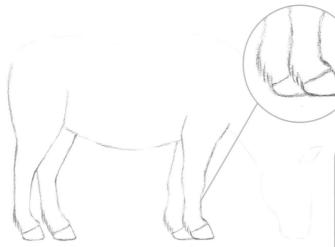

4 Erase the box and dashed line, and refine the pony's legs and hooves.

FUN FACT

Shetland and Highland ponies have thicker tails, manes, and coats than other breeds. These protect the ponies' bodies in cold weather.

5 Draw the pony's tail and mane.

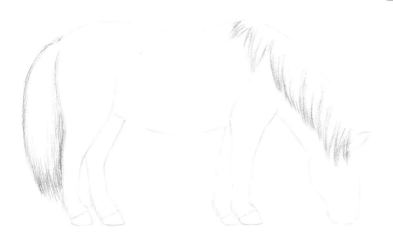

6 Draw the features of the head, and refine the forelock, ear, nostril, cheek, chin, and muzzle.

7 Shade the tail, mane, nostril, and eye shapes.

8 Refine the mane and tail with darker strokes, creating sections and deeper shadows.

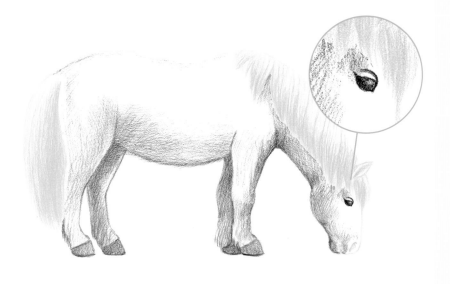

9 Shade the body with gradations and shadows. Erase a highlight from the eye.

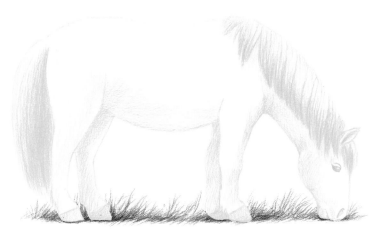

10 Draw grass and weeds around the pony's hooves, and shade the ground below.

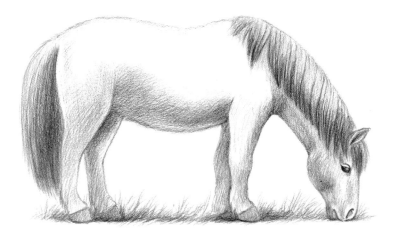

11 Refine the shading of the head, chest, and flank.

how to draw a horse

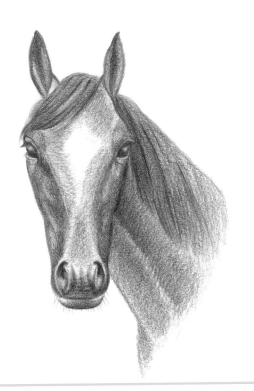

Steps: 11

Difficulty: ○ ○ ○ ○ ○

When viewed from the front, the horse's head has subtle angles and curves, as you'll learn when you draw this equine portrait. Occasionally rotate your paper upside down to check that the parts are balanced and symmetrical.

1 Draw a vertical line divided into four equal parts. Draw an intersecting horizontal line through the second mark from the top.

2 Add two more horizontal lines, one at the top and one at the bottom, and connect all three horizontals with diagonal lines.

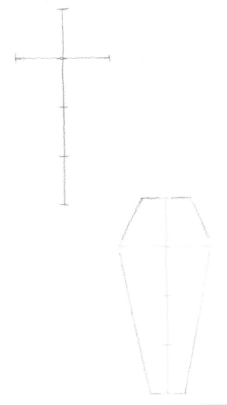

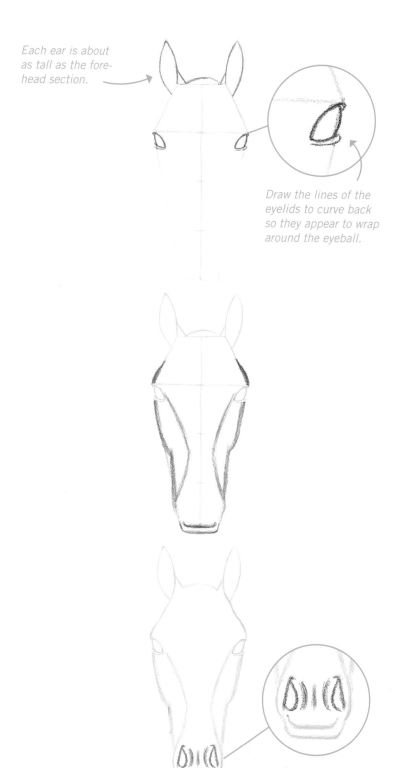

Each ear is about as tall as the fore-head section.

Draw the lines of the eyelids to curve back so they appear to wrap around the eyeball.

3 Around the upper part of the shape, draw the main outlines of the horse's ears and eyes.

4 Draw in the remaining shapes of the head with soft lines.

5 Erase any construction lines that are still visible, and draw the horse's nose.

6 Draw the neck and shoulder.

7 Shade the horse's ears and mane.

8 Shade the head except for the eyes and an irregular-shaped patch in the center. Shade the neck and shoulder.

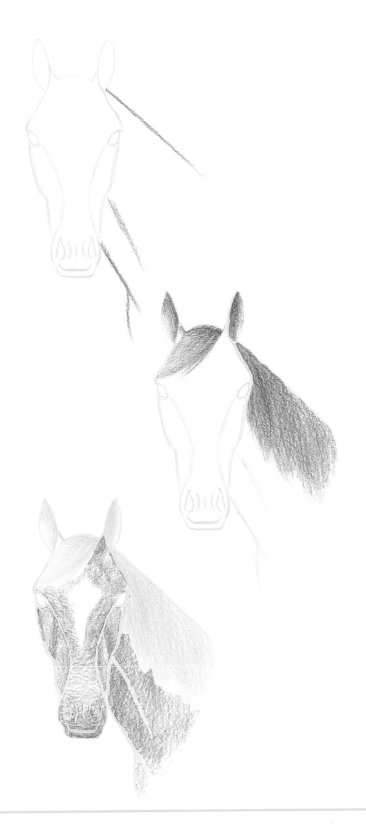

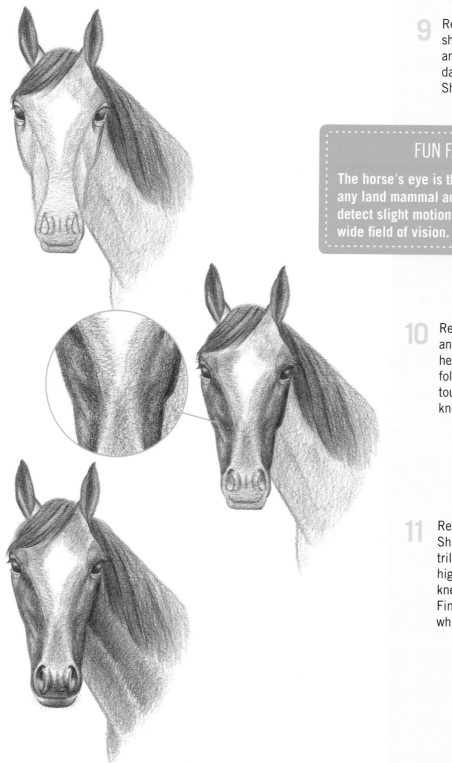

9 Refine the shading of the ears and mane with darker strokes. Shade the eyes.

FUN FACT

The horse's eye is the largest of any land mammal and helps it detect slight motions in a very wide field of vision.

10 Refine the cheeks and sides of the head with shading followed by light touches with a kneaded eraser.

11 Refine the neck. Shade the nostrils, and shape highlights with a kneaded eraser. Finally, add a few whiskers.

arabian horse

Steps: 11

Difficulty: ● ● ● ○ ○

The Arabian horse is powerful and elegant. It has strong chest, neck, and leg muscles; large nostrils and a slightly down-curved (or *dished*) nose; and a slightly shorter back than other breeds of horses.

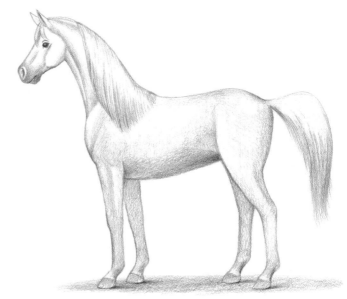

1 Draw a bean shape that's large on the left and angles up at the right.

The shape is two times wider than it is tall.

2 Draw the basic shapes of the horse's neck and head.

The length of the neck is the same as the height of the body.

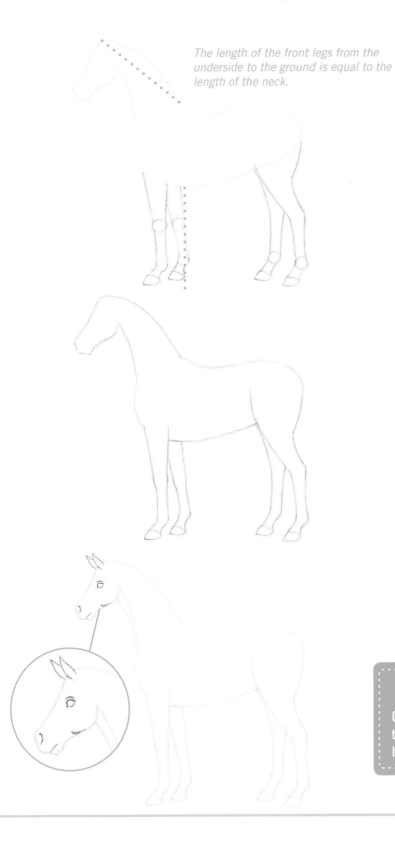

The length of the front legs from the underside to the ground is equal to the length of the neck.

3 Draw the horse's legs using circles to help create the bulges of the joints.

4 Erase the construction lines and interior parts of the circles, and smooth the lines of the legs.

5 Draw the eye, nostril, mouth, and ears. Smooth the lines of the head.

FUN FACT

Compared to other breeds of horses, the Arabian horse has one fewer bone in its spine and 2 fewer ribs.

6 Draw the outer edges of the horse's mane and tail.

7 Shade the head, the part of the mane just above the horse's forehead (the *forelock*), and the upper neck.

8 Draw long, repeating lines down the mane and tail.

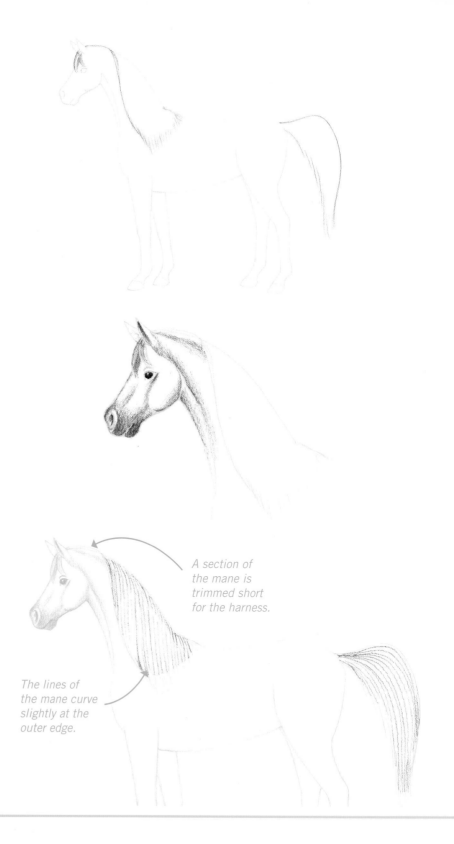

A section of the mane is trimmed short for the harness.

The lines of the mane curve slightly at the outer edge.

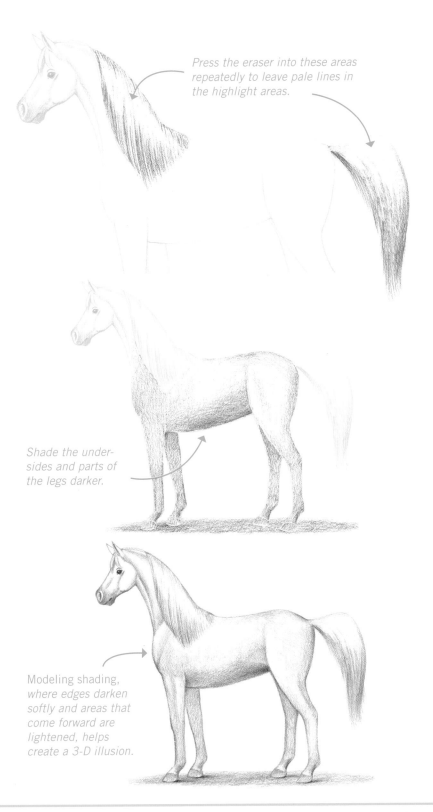

Press the eraser into these areas repeatedly to leave pale lines in the highlight areas.

9 Shade the mane and tail at the lower edge, and lighten the highlight area of each with a rubber eraser.

Shade the undersides and parts of the legs darker.

10 Shade the body and legs of the horse as well as the shadow below.

Modeling shading, where edges darken softly and areas that come forward are lightened, helps create a 3-D illusion.

11 Erase highlights into the body, and darken the undersides and outsides of some edges.

how to draw an appaloosa horse

Steps: 11

Difficulty: ● ● ● ○ ○

The Appaloosa is a smaller horse that's sturdy, spirited, and intelligent. The breed's markings cover a wide range of looks, including the leopard spots shown here, as well as snowflake, frost, blanket, and solid.

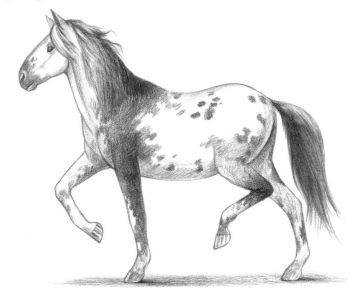

1 Sketch a bean shape that's about 5 inches (12.5cm) wide and 2¼ inches (5.5cm) tall in the middle.

The height of the bean shape is a little more than two of the lengths.

2 Draw the basic shapes of the horse's neck and head.

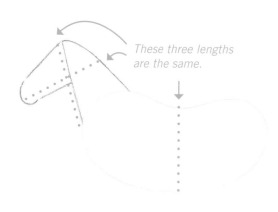

These three lengths are the same.

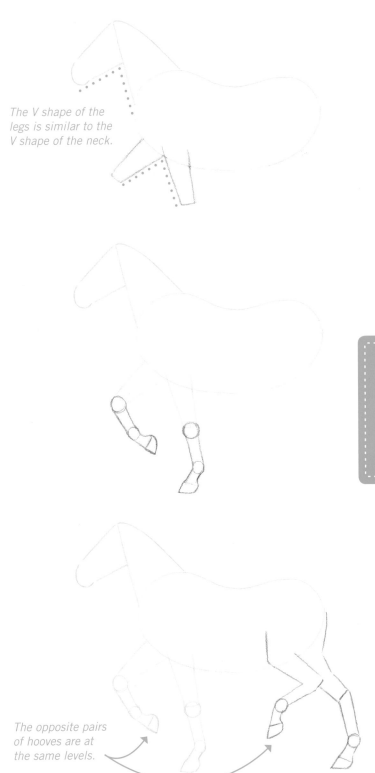

The V shape of the legs is similar to the V shape of the neck.

The opposite pairs of hooves are at the same levels.

3 Draw the upper parts of the forelegs.

4 Complete the forelegs with circles to indicate the joints.

FUN FACT

The name *Appaloosa* is likely derived from the Palouse River in Idaho, where the Nez Perce Indians valued these horses for use in racing, hunting, and battle.

5 Draw the rear legs.

6 Erase the construction lines, and refine the head, neck, and front legs by smoothing the lines and adding details.

Erase a section of the original neck line, bean shape, parts of the small circles, and two short lines.

7 Erase more of the original bean shape, and refine the lines of the belly, back, and rear legs.

8 Sketch the shapes of the eye, mane, and tail. Refine the contours of the head.

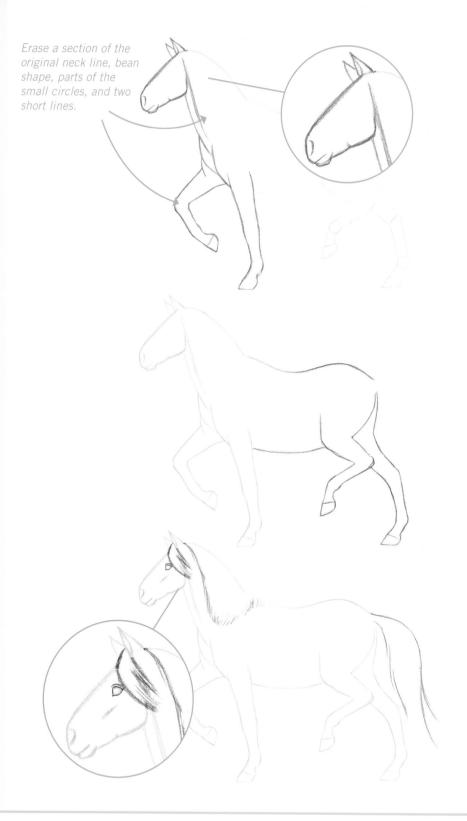

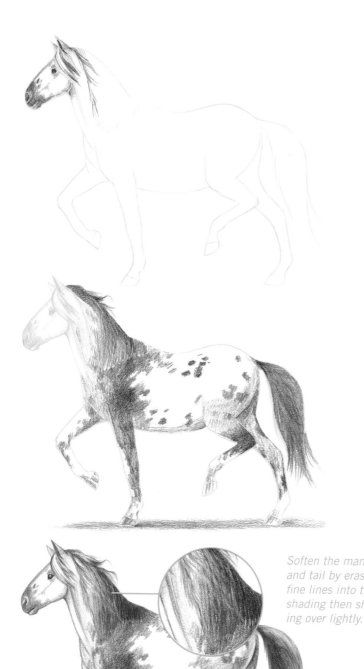

9 Begin shading the horse's markings, starting on its head. Shade the eye, the ears, and the part of the mane just above the horse's forehead (the *forelock*).

10 Shade the markings on the body, the tail, and the remainder of the mane. Add a cast shadow.

Soften the mane and tail by erasing fine lines into the shading then shading over lightly.

11 Intensify the dark shading of the mane and tail, the dark markings, the striped hooves, and the shadow below.

llama

Steps: 11

Difficulty: ● ● ● ○ ○

Llamas have fluffy wool similar to sheep. Shade the contours of the llama's coat with a soft back-and-forth shading line. Then draw the wool with individual strokes using the tip of your pencil and very little pressure.

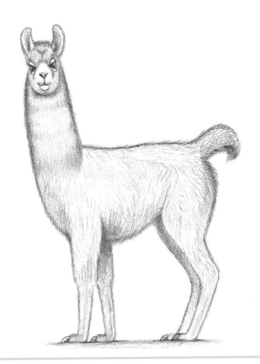

1 Draw a light grid two squares wide and three squares tall.

2 Draw the llama's body in the middle two boxes.

3 Draw the neck, head, and ears in the top left boxes.

4 Complete the contours of the legs in the bottom two boxes. Erase the grid lines.

5 Shade the soft V at the forehead, and draw the Vs of the eyes and nose with the tip of your pencil.

6 Complete the facial features.

7 Draw the feet and nails.

8 Shade the tail with two J shapes.

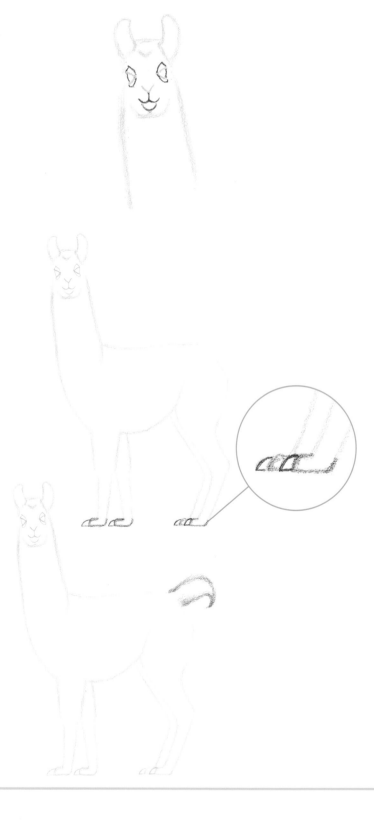

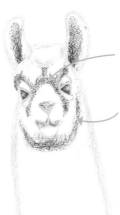

Begin by shading an upside-down U shape between the eyes.

Shade the forehead and cheeks with short, repeating strokes.

9 Shade the llama's head and face.

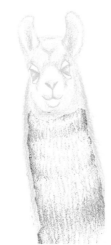

10 Shade the neck with repeating, short, vertical strokes.

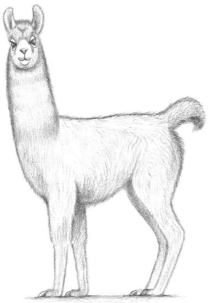

11 Shade and draw fur texture across the body and legs with short strokes that change direction. Add a shadow below.

puppy

Steps: 5

Difficulty: ○ ○ ○ ○ ○

Puppies are adorable and fun to draw. Here, the front view of the pup's head is a foreshortened view, or turned toward you, while the body is sideways. Create depth between the nose and eyes by shading dark to light in gradations.

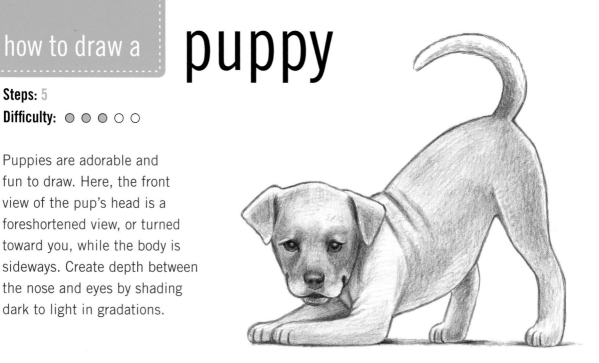

1 Draw the outline of the tail, back, and hind legs using a broken line.

2 Draw the shape of the head; add the basic outlines of the eyes, nose, muzzle, and ears; and draw the front legs level with the hind paws.

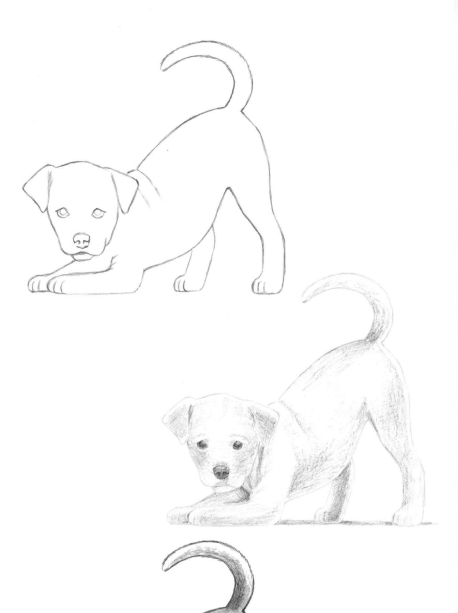

3 Fill in the broken lines, and refine the ears, eyes, nose, and muzzle.

4 Shade the head and body with strokes that follow the directions of the contours. Add the shadow at the paws.

5 Deepen and refine shaded areas to create depth, and erase highlights in the eyes, nose, brow, and muzzle.

FUN FACT

Head bowed and hind end raised is puppy talk for "Let's play!" It's called a play bow, and the dog might also bare its teeth in a goofy grin and run away or jump around in circles in an effort to get you to join in the fun.

labradoodle

Steps: 11

Difficulty: ○ ● ● ● ○

A Labradoodle's fur is a combination of tight curls and soft, wavy texture, thanks in part to the fur of the two parent breeds—Labrador Retrievers and Poodles. Vary the direction and tone of the fur pattern slightly as you draw for a natural look.

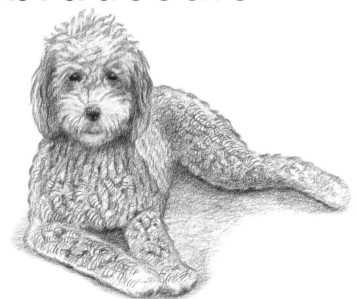

1 Sketch the contours of the Labradoodle's head using soft lines.

2 Draw the contours of the body.

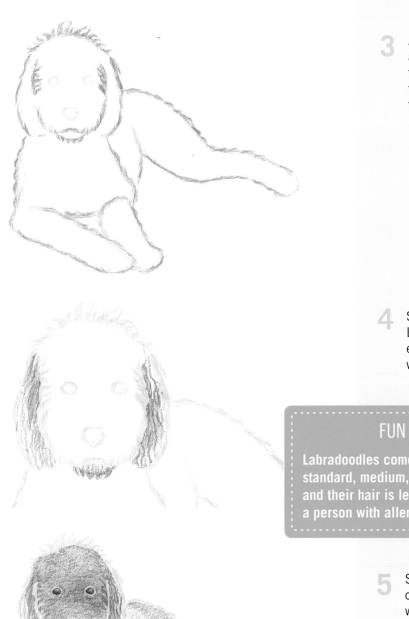

3 Add wavy shapes and curves along the outside contours to create fur texture.

4 Shade the Labradoodle's ears and chin with wavy lines.

FUN FACT

Labradoodles come in three sizes—standard, medium, and miniature—and their hair is less likely to bother a person with allergy to pet dander.

5 Shade the interior of the dog's body with repeating angled lines. Shade the eyes dark, and erase highlights.

6 Using a kneaded eraser, make lines around the eyes and radiating from the nose to create more fur texture.

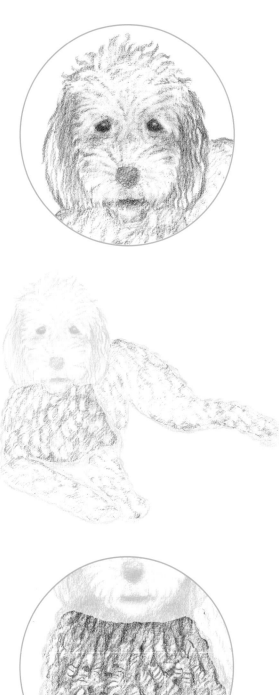

7 Erase short marks that flow down the chest and legs for texture.

8 Draw short curving lines across the erased marks on the chest, and shade between the marks.

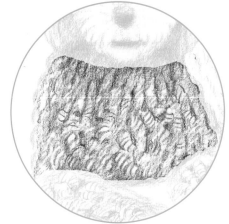

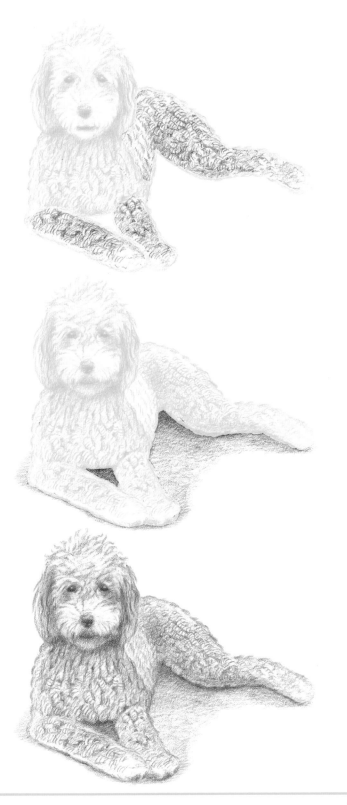

9 Shade diagonal marks down the abdomen, and create more of the curved lines and shadow texture over the rear leg.

10 Shade the ground around the Labradoodle with short horizontal and diagonal strokes.

11 Refine the top of the head, eyes, nose, and mouth with a kneaded eraser. Shade the abdomen a bit more.

kitten

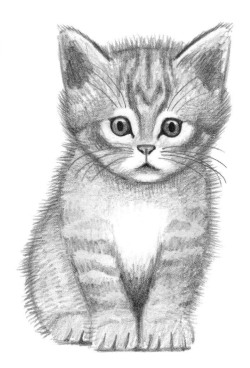

Steps: 5

Difficulty: ⬤ ⬤ ⬤ ⬤ ○

When drawing this curious kitten, sketch the outlines with multiple strokes using the side of your pencil tip. This keeps the lines soft so they blend in with your final shading.

1 To create the kitten's face, draw two V shapes for the eyes and two shaded triangles joined by a line for the nose and mouth.

2 Draw the main shapes of the kitten's head.

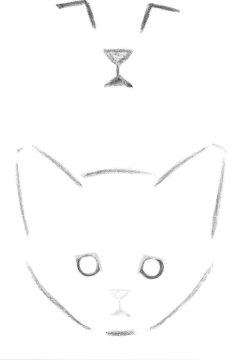

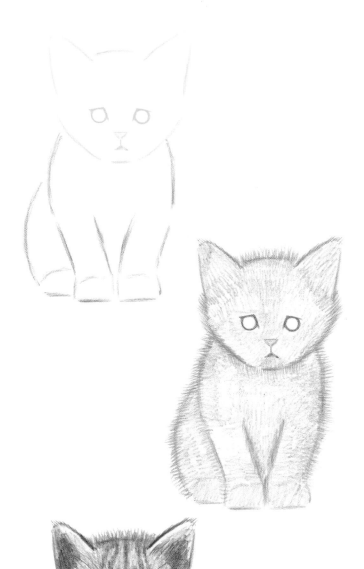

3 Sketch the outline of the little cat's body.

4 Make soft strokes that pass over the main contours and outward, and shade the body.

5 Erase around the eyes and at the mouth, ears, and chest. Add whiskers, and refine the kitten's eyes and body shading.

FUN FACT

Most cat breeds have three to five kittens per litter. The newborns won't open their eyes for the first week or two.

how to draw a maine coon cat

Steps: 11
Difficulty: ● ● ● ● ○

Maine Coon cats are large cats. They have long, thick hair and wide feet so they can live in areas where there's snow. Shade the darkest parts of the hair first and then soften it with short strokes that flow out to pointed tufts.

1 Sketch the shapes of the Maine Coon cat's head.

2 Sketch the outlines of the body and tail.

3 Add the basic shapes of the face, beginning with the nose, followed by the eyes, mouth, and chin.

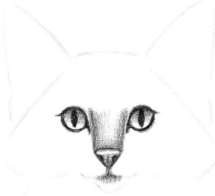

4 Refine the cat's eyes, nose, and mouth with dark shading and gradations.

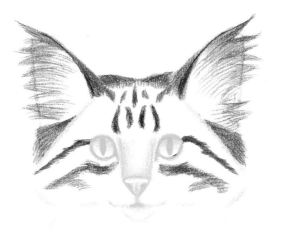

5 Shade the tufts of the ears and the face markings.

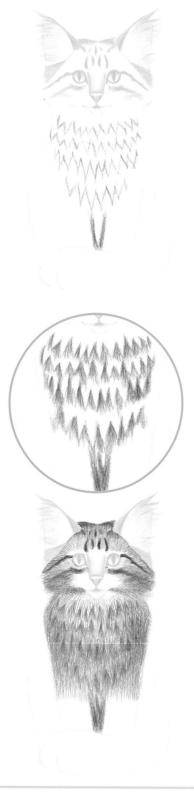

6 Sketch rows of curved V shapes across the chest, and shade the V shape of the front legs.

7 Shade the upward-pointing parts of the V pattern on the chest.

8 Shade the fur out from the center of the face and down the cat's chest.

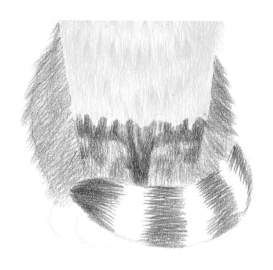

9 Shade the markings of the front legs and the stripes of the Maine Coon's tail.

10 Refine the tail and then the front and rear feet.

11 Use a sharp pencil to draw the Maine Coon cat's long whiskers.

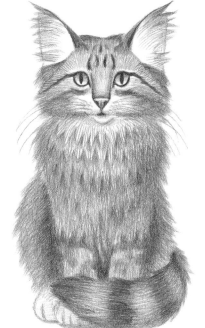

FUN FACT

Similar to their gentle nature, Maine Coons have distinctive soft voices that can sound like a bird's cooing and chirping.

how to draw a siamese cat

Steps: 11
Difficulty: ⬤ ⬤ ⬤ ⬤ ○

This breed has a distinctive elegance, with its elongated head, slender body, and smoky markings. Begin the effect of the Siamese's plush, dark fur by first shading a soft outline and then shading to the darkness you want in layers of short strokes.

1 Lightly sketch two connected squares. In them, draw the outline of the top of the cat's body using slightly broken lines.

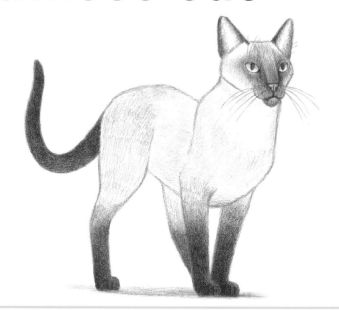

2 Sketch two more squares below the first ones, and draw the cat's lower body, again using broken lines.

3 Erase all the squares, and connect and refine the lines of the cat's upper body.

4 Do the same with the lines of the cat's lower body.

5 Draw the features of the face.

6 Shade the ears with gradations.

7 Shade the face with gradations.

FUN FACT

The marking of the Siamese cat's striking light-to-dark coat is due to a gene mutation resulting in the cat's fur being colored according to body temperature. The hairs are darker in cooler areas and lighter where the body is warmer.

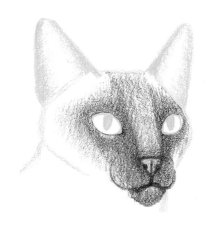

8 Shade the legs with a medium gray tone that gradually becomes lighter the higher on the legs it gets.

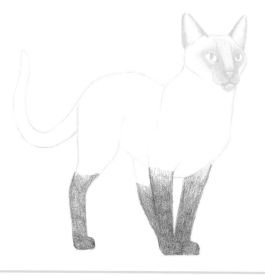

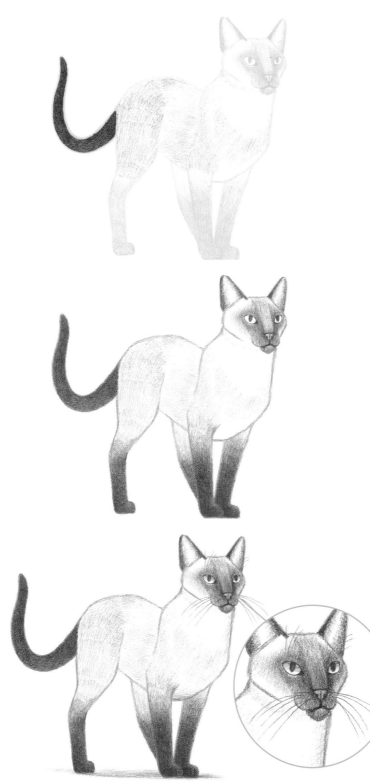

9 Shade the cat's tail and body with strokes that gradually change direction.

10 Further shade the legs with a range of dark gradations.

11 Add gradations to the eyes, and draw the cat's whiskers, and shade the shadow on the ground

tuxedo cat

Steps: 11
Difficulty: ○ ○ ○ ○ ○

The patterns in this breed's fur make it look as if it's wearing a tuxedo, hence the name. If you have one of these finely dressed felines, you can shade your drawing to resemble your pet. Build the shading slowly in layers for a softer look.

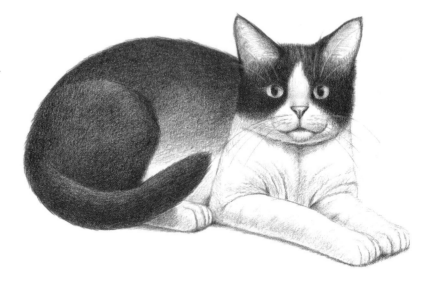

1 Lightly sketch a box 4½ inches tall by 7¼ inches wide (11.5 by 18.5cm). Divide it in half with a vertical line.

2 Sketch the main edges of the cat in the boxes.

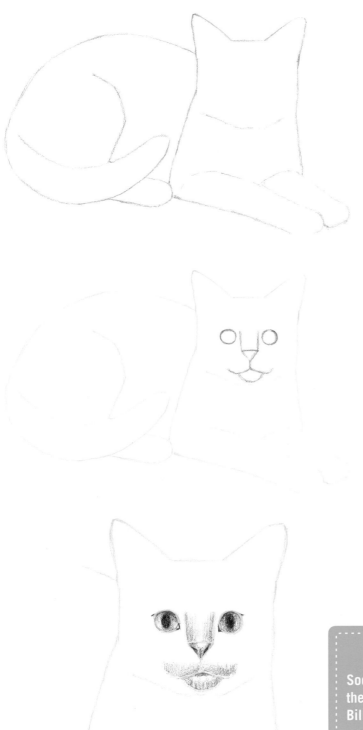

3 Erase the box, and connect and smooth the lines of the cat's head and body.

4 Draw the feline's facial features.

5 Shade and refine the eyes, nose, and mouth.

FUN FACT

Socks the cat was famous for being the pet tuxedo cat of U.S. President Bill Clinton while he was in office.

6 Shade the cat's facial fur pattern with short, horizontal strokes.

7 Shade the back and tail with short strokes that follow the direction of the outside lines.

8 Shade the deeper shadow areas of the cat's white fur.

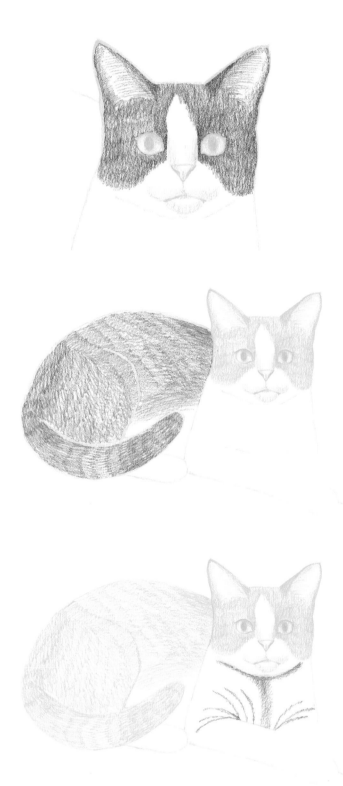

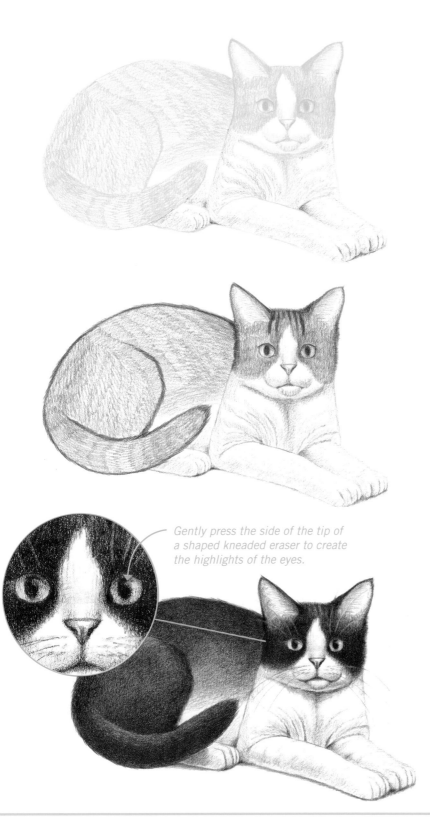

9 Shade the pale areas of the white fur.

10 Create the fur texture stroke by stroke along the outside edges of the dark fur and at the top of the head.

Gently press the side of the tip of a shaped kneaded eraser to create the highlights of the eyes.

11 Darken the cat's black fur, and refine the face. Erase the white of the whiskers, and make eye highlights with a shaped kneaded eraser.

chicken

Steps: 11

Difficulty: ○ ○ ○ ○ ○

A female chicken, or a *hen,* has a thick and soft feathery covering. Her feathers are smaller around her face and head and much larger at her tail. The contour in this drawing shows how the texture changes from smooth to fluffy to rough.

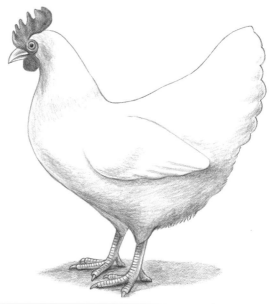

1 Draw the downward curves of the beak, and for the eye, draw two circles above the beak's middle line.

2 Draw the chicken's comb above her head and her wattle below her beak.

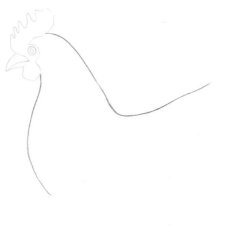

3 Draw the chicken's neck, chest, and sloping back.

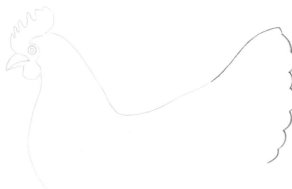

4 Add the curves of her tail feathers.

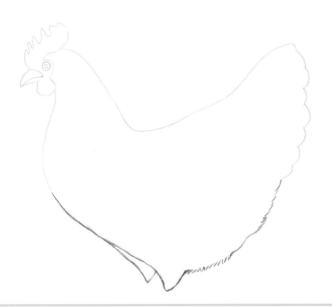

5 Sketch the lower part of the chicken's body with short lines, and make two downward points where her legs will go.

6 Begin the near leg with a downward curve and an angled line.

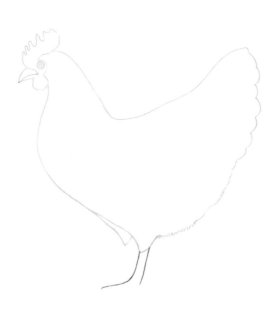

FUN FACT

The natural posture of the chicken's foot is curved around a branch, not walking, because this bird developed from jungle fowl that perched in trees.

7 Add the toes, and leave little spaces at the tips of the toes for the claws.

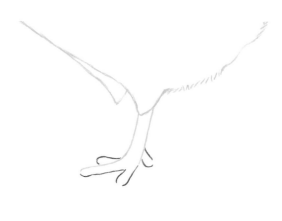

8 Draw the claws using slightly curving lines.

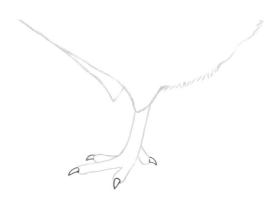

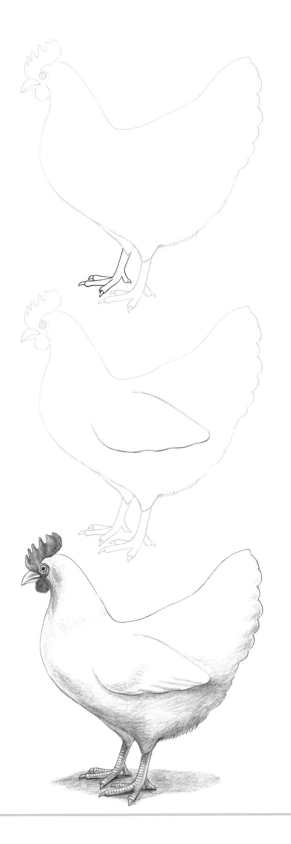

9 Complete the chicken's other leg and foot.

10 Draw the hen's small wing with a curving line that begins and ends softly.

11 Shade the hen's head and lower body with short lines that change direction as they follow her body. Shade the feet and cast shadow.

duck

Steps: 11

Difficulty: ○ ○ ○ ○ ○

Ducks are common farm animals, but they're increasingly becoming popular with urban dwellers as pets and for fresh eggs. When drawing this bird, create interest and 3-D illusion on her white feathers by creating light areas in the shadows and with gradations.

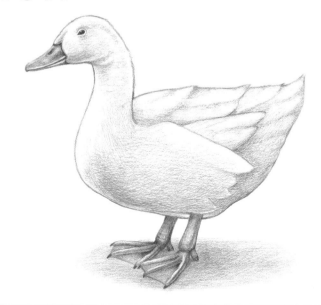

1 Sketch the shapes of the head, beak, and neck.

2 Sketch the main outline of the duck's body, legs, and feet.

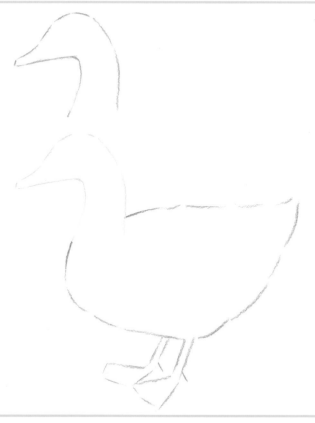

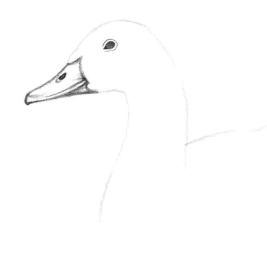

3 Refine the beak. Draw the duck's seed-shaped eye with a partial outline.

Add a few small lines to the neck to create a feathery texture.

4 Draw the wings and the duck's main feather sections.

5 Reshape the legs, draw the toes and claws, and add the webbed sections.

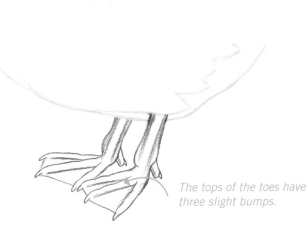

The tops of the toes have three slight bumps.

6 Shade the duck's beak and the head, leaving some highlights unshaded. Refine highlights with a kneaded eraser.

Darken the deepest shadows before erasing highlights.

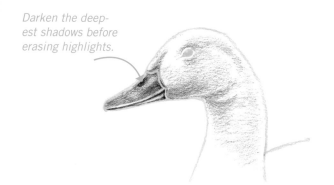

7 Shade the duck's chest with short strokes, and shade the rest of the body feathers.

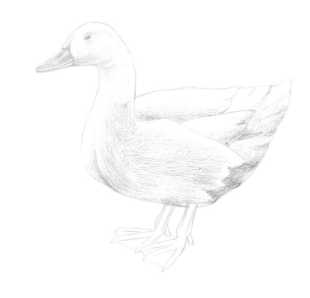

8 Shade both feet like the near one, and add dark shading to both like the far foot.

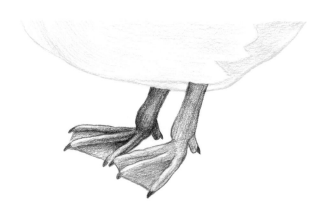

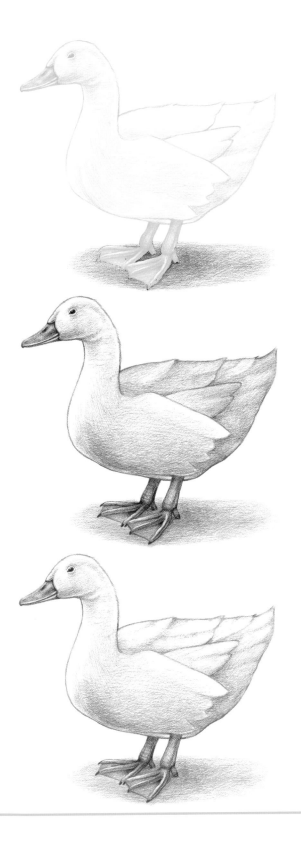

9 Pencil in the shadow on the ground using horizontal strokes, followed by a layer of angled strokes.

10 Darken the shading of the duck's back feathers.

11 Create highlights on the back feathers by pressing them repeatedly with a kneaded eraser.

how to draw a cockatiel

Steps: 11

Difficulty: ● ● ● ● ○

Cockatiels are easily identified by their distinctive head, or crest, feathers. The view from above in this drawing creates many interesting angles. Draw the bird's nostrils, chest, and wingtips aligned with a 45-degree reference line so all these parts appear realistic.

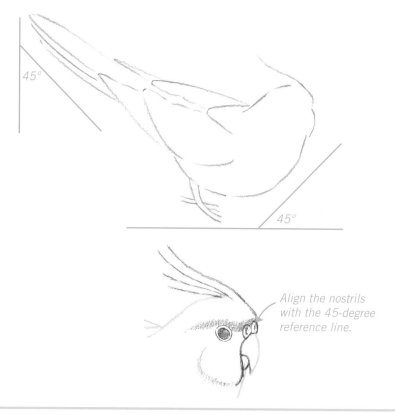

1. Lightly draw two reference lines, one at 45 degrees to the left edge of the page and one at 45 degrees to the bottom edge. Draw the cockatiel's main shapes in relation to the 45-degree lines.

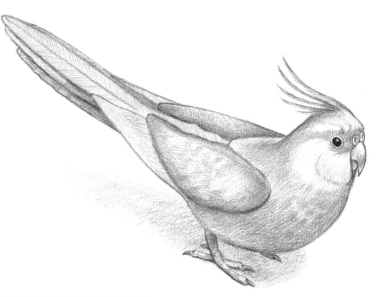

45°

45°

2. Draw and shade the main parts of the cockatiel's head.

Align the nostrils with the 45-degree reference line.

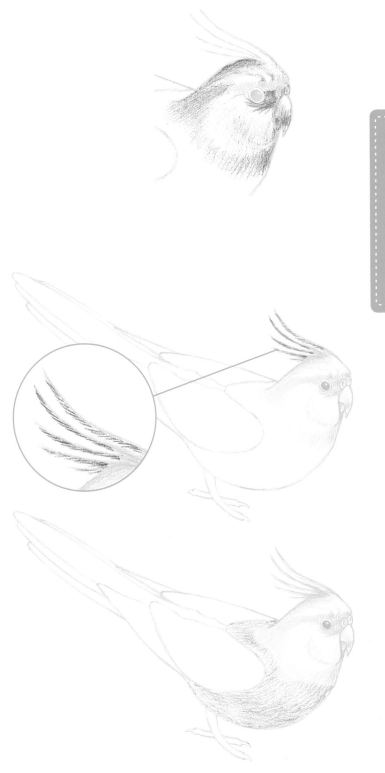

3 Create a 3-D illusion on the head with stroke-by-stroke shading.

FUN FACT

Look to the cockatiel's crest feathers to read the bird's mood. When the feathers stand straight up, the bird is alarmed or excited; when the feathers are at less of an angle, the bird is relaxed or happy; when the feathers are flat, the bird may be angry, frightened, or flirting.

4 Using a sharp pencil, draw the barbs of the crest feathers.

5 Shade the chest and belly using rows of repeating strokes that gradually change angles around the bird's body.

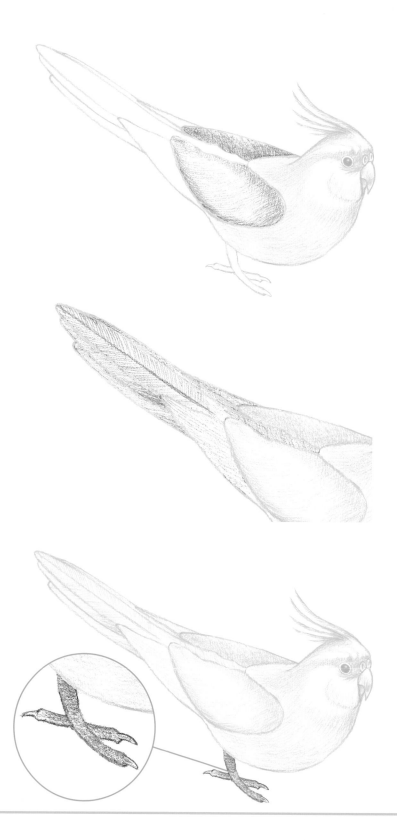

6 Shade the cocka-
tiel's forewings to
be darker at the
edges.

7 Shade the sides
of the tail feath-
ers with repeating
strokes.

8 Refine the bird's
foot, and add the
shading.

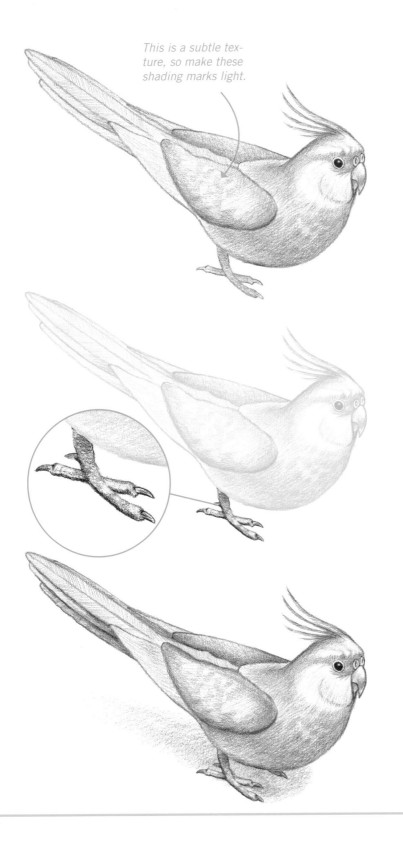

This is a subtle texture, so make these shading marks light.

9 Create small feather texture across the forewings with patches of short repeating marks.

10 Darken the shading of the foot, and erase highlights with a kneaded eraser.

11 Add the inside toe of the far foot. Finally, intensify the dark shadows and shade a shadow below the bird.

tarantula

Steps: 11

Difficulty: ● ● ● ● ○

This rose hair tarantula is a native of Chile and is relatively docile, but it has fangs and might bite or flick tiny irritating (*urticating*) hairs when provoked. Like all tarantulas, it must be handled gently to avoid injuring its legs and abdomen.

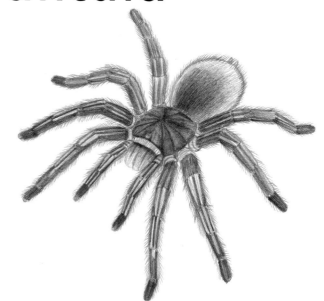

1 Begin the head section (the *cara-pace*) by sketching two light pairs of lines in a distorted rectangle shape.

The angles of the lines are most important, so make the shape carefully and don't include the corners.

2 Refine the form by rounding it and adding a narrow curved rectangle at the left, or front. Erase any visible soft lines you drew in step 1.

The midline is curved because the surface of the carapace rises slightly in the center.

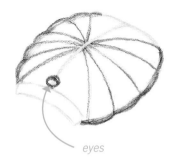

eyes

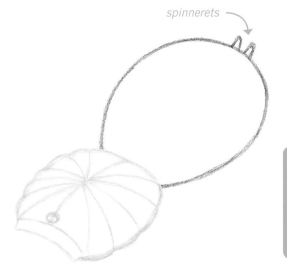

spinnerets

3 Draw a midline that curves similar to the upper edge.

4 Add curved cross-contour lines and outer curves. Add the small oval cluster of the eyes. (It has eight.)

5 Draw the abdomen and the spinnerets.

FUN FACT

As they grow, tarantulas occasionally shed their complete covering of skin in a process called *molting*.

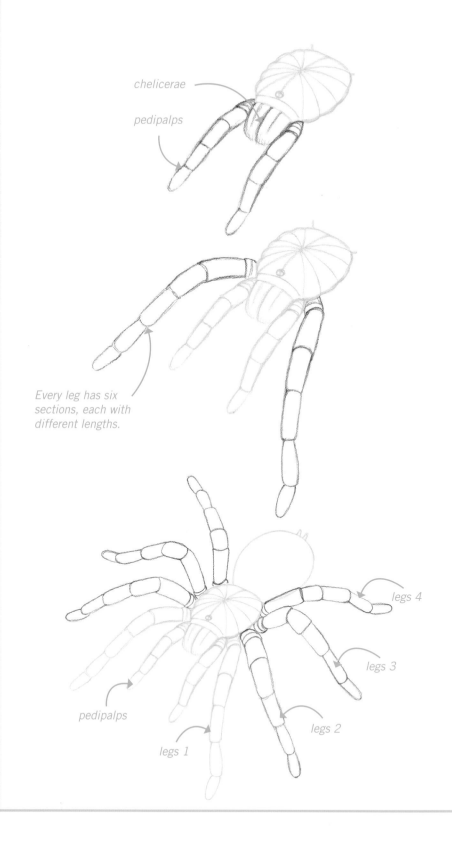

6 Draw the hairy covering of the fangs (the *chelicerae*) and the short front legs (the *pedipalps*).

chelicerae

pedipalps

7 Draw the pair of front legs (legs 1).

Every leg has six sections, each with different lengths.

8 Draw the remaining pairs of legs—2, 3, and 4.

legs 4

legs 3

pedipalps

legs 2

legs 1

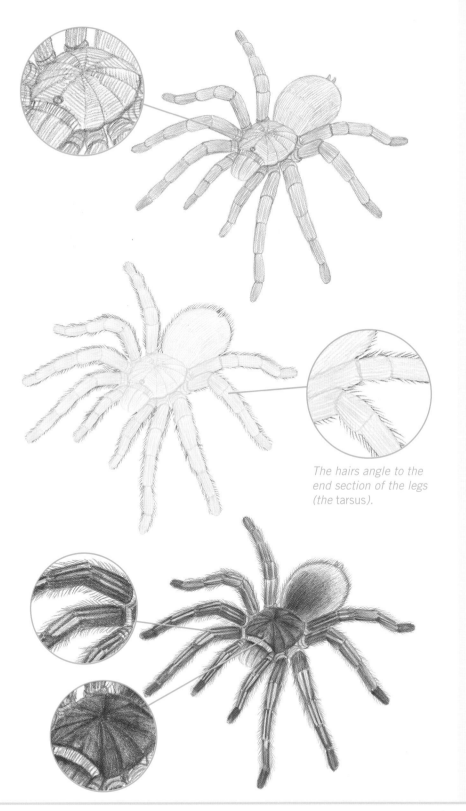

9 Shade the entire tarantula with repeating short strokes.

10 Using a sharp pencil, draw short strokes along the edge of the legs and abdomen.

The hairs angle to the end section of the legs (the tarsus).

11 Darken the shading of the carapace, the abdomen, and the pattern on the legs.

hedgehog

Steps: 11

Difficulty: ○ ○ ○ ○ ○

This fun little pet has a striking contrast of textures, with its prickly back and plush belly. Draw the hedgehog's fur pattern outward from the eyes, across the sides, and down.

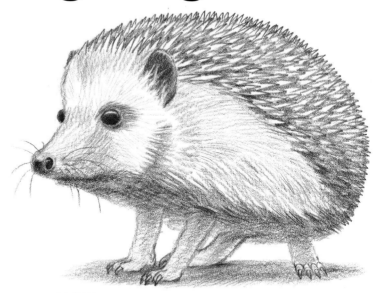

1 Lightly sketch a rectangle 3¾ inches (9.5cm) tall by 5 inches (12.5cm) wide.

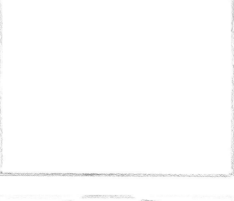

2 Inside the rectangle, sketch the main shapes of the hedgehog.

Draw the nose, sweep upward, and go around the back first. Then make the mouth, chin, and legs before adding the interior parts.

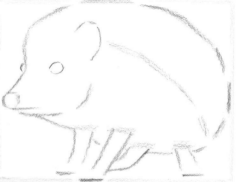

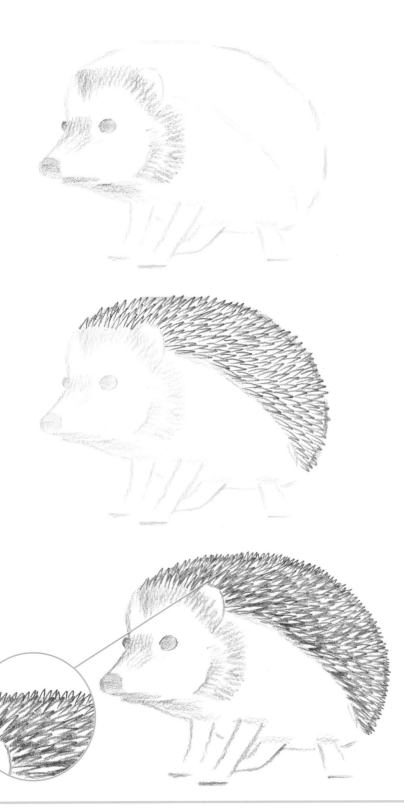

3 Erase the box, and shade the hedgehog's eyes, nose, mouth, and head using the side of your pencil tip.

4 Draw the hedge-hog's quills with repeating V shapes that gradually change direction as you work across the back.

5 Draw very small V shapes at the top curving edge, and shade around lower quills.

6 Shade the legs and underbody. Draw strokes angling upward where the hedgehog's underbody becomes its side.

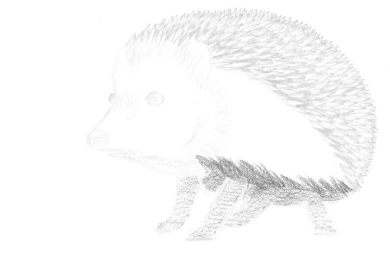

7 Add lighter strokes to create the softer hairs beneath the quill area.

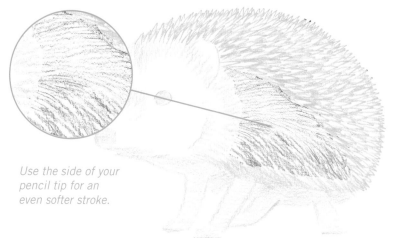

Use the side of your pencil tip for an even softer stroke.

8 Shade the eyes and nose. The nostril has an oval shape with a curving tail. Add the whiskers, too.

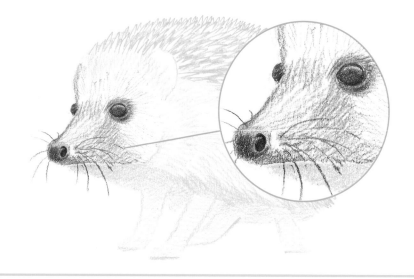

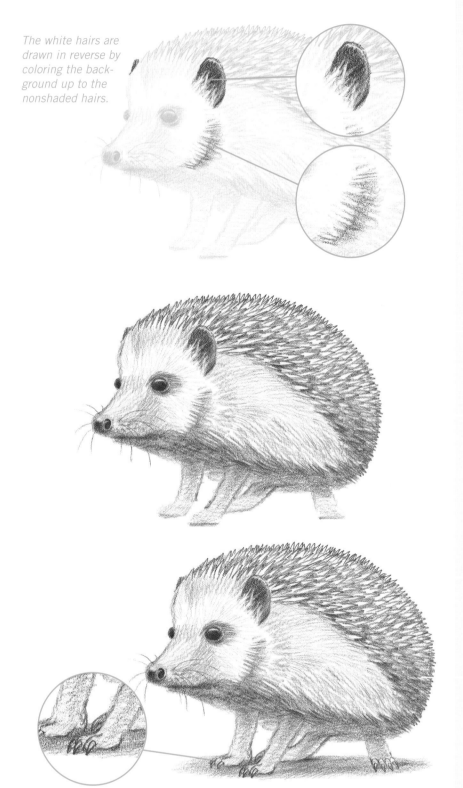

The white hairs are drawn in reverse by coloring the background up to the nonshaded hairs.

9 Shade thin V shapes to make the light fur at the ears and jaw.

10 Darken the shading of the underside where it meets the pale side hairs.

11 Draw the hedgehog's nails, add the details of the toes, and make the shadow below.

ferret

Steps: 11

Difficulty: ○ ○ ○ ○ ○

Ferrets are fun pets that often have goofy personalities. You draw this sable ferret's ears, eyes, nose, mouth, and chin at the same angle as the initial reference line.

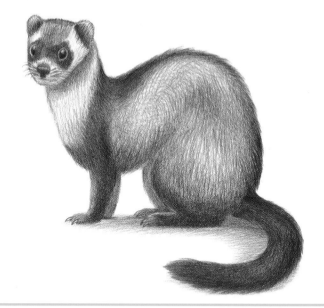

1 Draw a line angling down at the right. Using this line as a reference, draw the features of the ferret's head.

The ferret's eye and ear and the interior vertical line on the left are narrower because the head is turned.

2 Erase the construction line, and sketch the remaining body edges in sections.

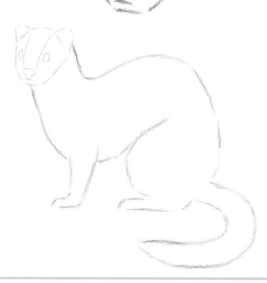

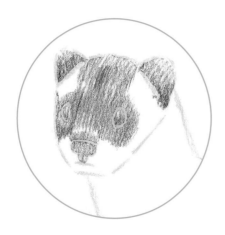

 Shade the nose, eyes, mask, and ears.

4 Shade the body and tail.

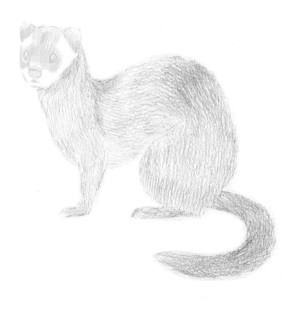

5 Add fur texture by drawing repeating short lines at the nose and the outer edge of its head.

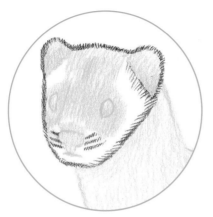

6 Shade the dark areas of the fur on the ferret's body.

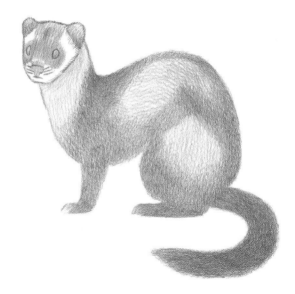

7 Shade the eyes darker, and leave highlights. Shade the nose, mask, and ears darker.

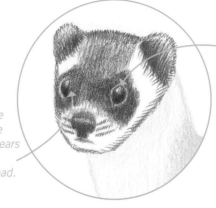

Part of the pale ring around the left eye disappears because of the angle of the head.

Leave a pale ring around the eyes by not shading there.

8 Shade the darkest parts of the fur at some edges of the black areas.

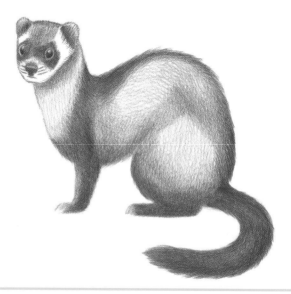

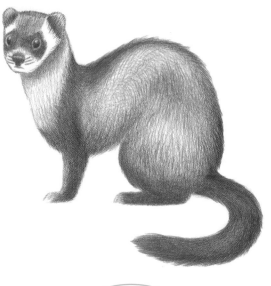

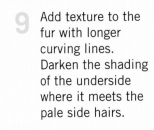

9 Add texture to the fur with longer curving lines. Darken the shading of the underside where it meets the pale side hairs.

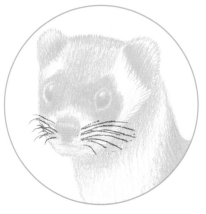

10 Using a sharpened pencil, draw the ferret's whiskers.

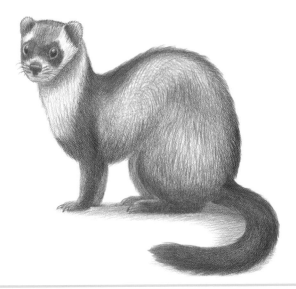

11 Add the ferret's far legs and a shadow below.

rat

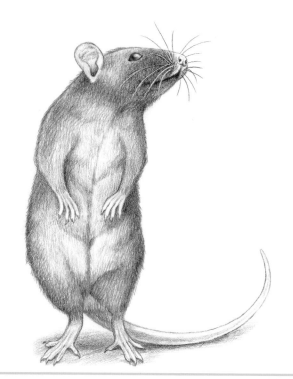

Steps: 11
Difficulty: ⬤ ⬤ ⬤ ⬤ ○

The toes and tail of this rat stretch to provide support while he's standing. Use contrast of tone to help the rat's whiskers, ear, nose, feet, and tail stand out.

1 Working in sections, draw the shapes of the rat's head.

2 Draw the main shapes of the rat's body in sections.

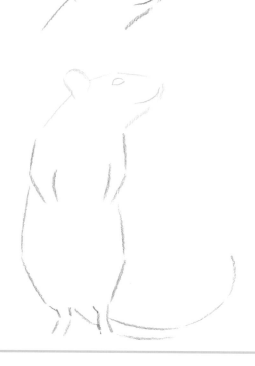

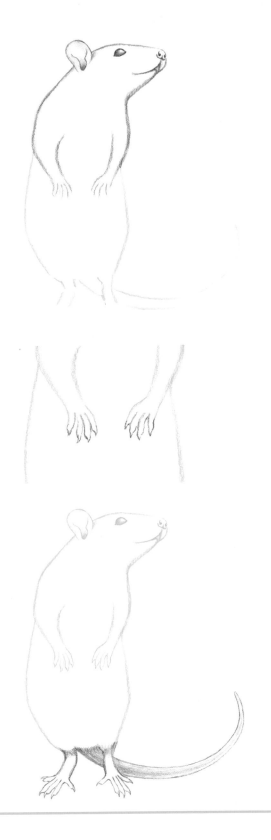

3 Smooth and refine the lines of the head and front legs.

4 For the front paws, draw the top line of each toe followed by the lower line and then the claw.

5 Draw the feet and tail. Shade the tail and the fur where the hind feet and the tail join the body.

6 Draw fur texture over the outer edges of the rat's body, and shade the fur sections.

7 Make the whiskers that fall over the rat's cheek with your fingernail or a paper clip, and draw the remaining ones with a sharp pencil.

Tracing these whiskers makes a crevice in the paper so when you shade the head in step 8, these whiskers remain light.

8 Shade the head with the side of your pencil's tip and then shade short lines over the rat's body.

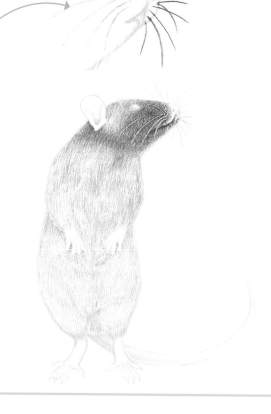

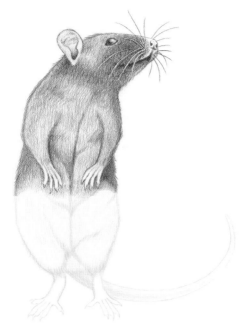

9 Refine the shading of the rat's upper body, eye, mouth, and front feet.

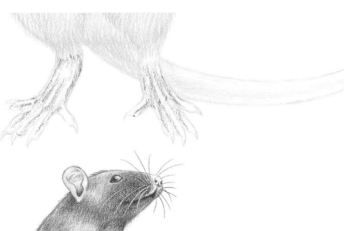

10 Refine the shading of the back feet.

11 Refine the shading on the rat's lower body, and add the shadow beneath the body and the tail. Use a kneaded eraser to lighten some spots on the rat's chest and abdomen.

sugar glider

Steps: 11
Difficulty: ○ ○ ○ ○ ○

These plush marsupials are nocturnal and live in colonies with other sugar gliders. They have delicate and agile feet, perfect for climbing. They also have extra skin between their fore- and hind legs that, when extended, enables them to float from tree to tree.

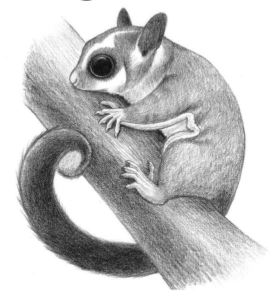

1 Sketch the two angled lines of a tree limb, and draw the shapes of the sugar glider's head and upper body, working in sections.

2 Sketch the rest of the edges of the tree, the sugar glider's body, and its tail.

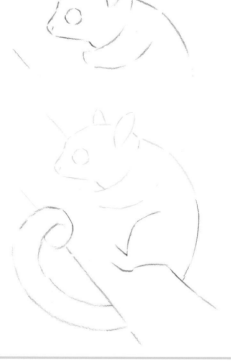

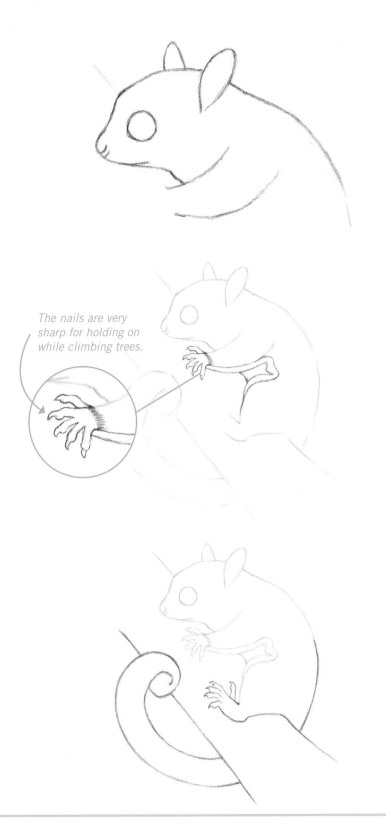

The nails are very sharp for holding on while climbing trees.

3 Smooth and connect the lines of the face and ears.

4 Draw the sugar glider's forearm and foot plus the skin folds starting at the lower foot.

5 Refine the remaining edges, and draw the hind foot.

6 Shade the dark markings of the sugar glider's face and ears. Shade the eye, too, leaving a thin white ring.

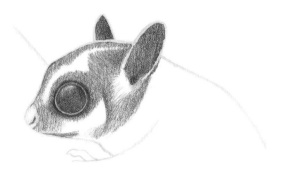

7 Shade the neck with rows of repeating strokes that overlap at different angles.

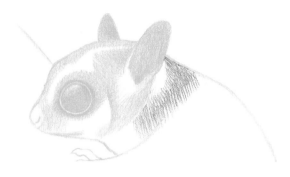

8 Shade the body and tail with overlapping repeating strokes using the side of your pencil tip.

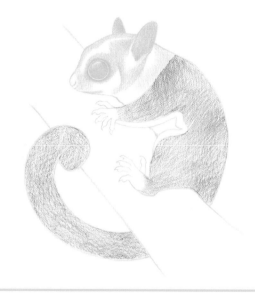

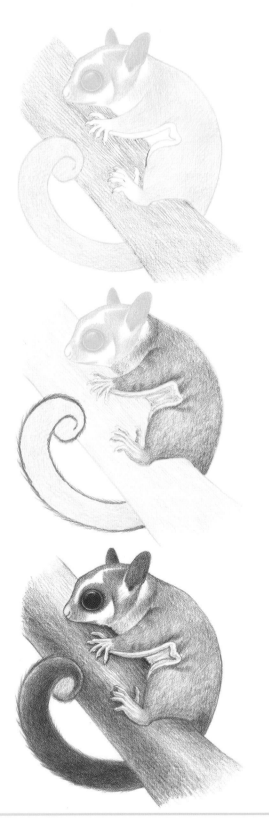

9 Shade the tree with repeating strokes running its length.

10 Darken the shading of the feet and skin folds. Shade the hair texture along the outside edge of the tail.

11 Darken the tail fur, and shade the eye very dark, leaving a curved highlight.

FUN FACT

Like kangaroos and other marsupials, sugar gliders have a small pouch in which they carry their young. The baby sugar gliders live and feed in the pouch until they're strong enough to climb on their own.

macaw

Steps: 17

Difficulty: ○ ○ ○ ○ ○

These brightly colored parrots are found in the forests of Central and South America. Their agile feet can grasp hard-shelled nuts and seeds that the bird eats by cracking them apart with its extremely strong beak.

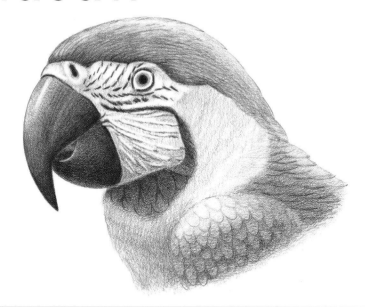

1 Sketch the broken outline of the forehead and the base of the macaw's beak. Draw the eye.

The eye angles down to the left toward the beak.

2 Complete the main shape of the upper beak.

The height of the macaw's beak is similar to the width of its forehead.

3 Add the outline of the lower beak.

4 Sketch the macaw's neck and upper chest.

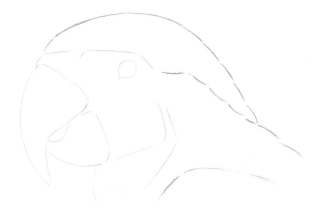

5 Draw the top of the macaw's head, upper back, and wing with a broken outline and curves.

6 Shade the beak, nostril, eye, and the dark patch of feathers beneath the beak.

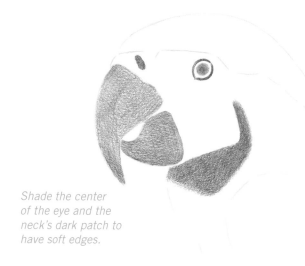

Shade the center of the eye and the neck's dark patch to have soft edges.

7 Shade the long area at the top of the head.

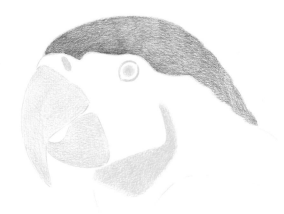

8 Shade the macaw's chest, neck, wing, and back with light and medium-dark tones.

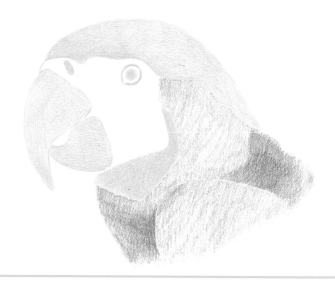

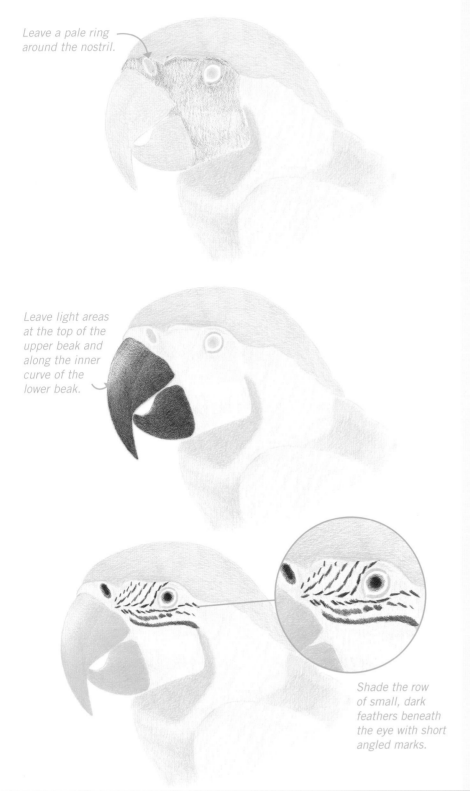

Leave a pale ring around the nostril.

Leave light areas at the top of the upper beak and along the inner curve of the lower beak.

Shade the row of small, dark feathers beneath the eye with short angled marks.

9 Shade a light tone on the cheek and around the eye and nostril.

10 Shade the macaw's upper and lower beak.

11 Shade the eye's pupil, the center of the nostril, and the small feathers near the eye.

12 Sketch U-shaped feathers in the dark patch below the beak.

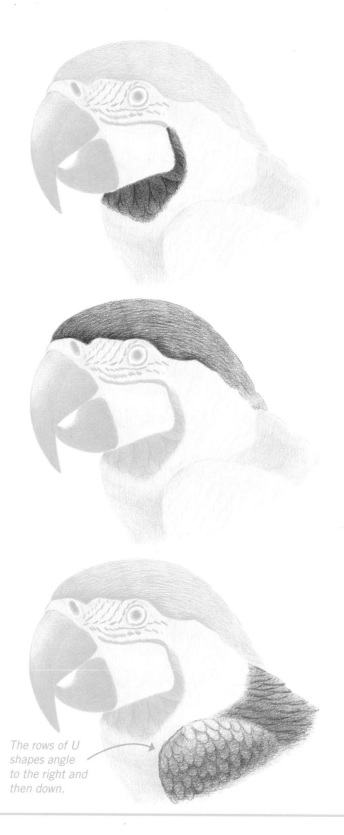

13 Draw feather texture on the head with short lines that follow the curve of the outside edge.

14 Draw horizontal curves on the back and U shapes in rows on the wing, and shade these areas.

The rows of U shapes angle to the right and then down.

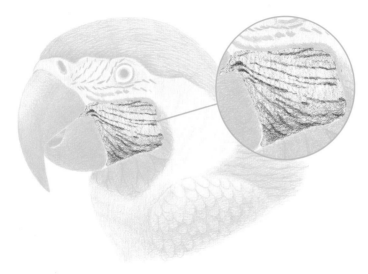

15 Sketch slightly wavy lines that angle up across the cheek to the beak.

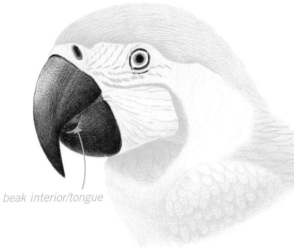

beak interior/tongue

16 Darken the lower parts and right edges of the beak as well as the eye and nostril. Shade the beak interior.

FUN FACT

The macaw's tongue has a bone inside it that helps the bird break apart its food.

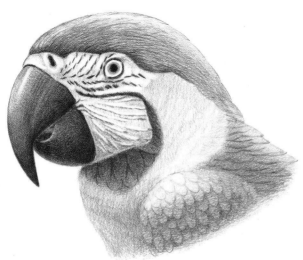

17 Erase highlights by lightly dragging or tapping a kneaded eraser across the top of the beak; around the nostril; along the tops of the head, back, and wing; and along the tops of the dark lines on the cheek.

calico cat

Steps: 17
Difficulty: ○ ○ ○ ○ ○

Calico is not a breed, but rather a color pattern of a cat's coat—usually black, white, and orange. The thick fur around the neck, also called a *ruff,* is typical of the Maine Coon breed and keeps the cat's neck warm in winter.

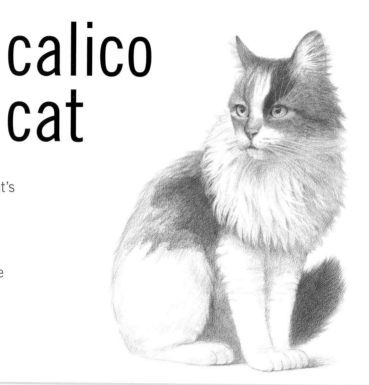

1 Make four short lines to mark vertical sections 2¾ inches (7cm) apart along the right edge of your paper.

You can erase these lines after completing the outlines of the body in step 6.

2 Sketch the main shape of the cat's head with a soft, broken outline. Make it slightly wider than it is tall.

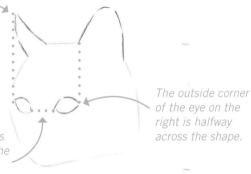

The outside corners of the eyes align with the left parts of the ears.

The distance between the eyes is the width of the eye on the right.

The outside corner of the eye on the right is halfway across the shape.

This point is directly below the ear and the corner of the eye on the right.

This point aligns with the lowest mark.

3 Draw the ears and then the eyes so they align with the points at the top of the head.

4 Add the nose and mouth.

5 Sketch the outside edge of the chest, leg, and front feet.

6 Draw the remaining outlines of the body and the ruff. Then erase the small vertical reference lines.

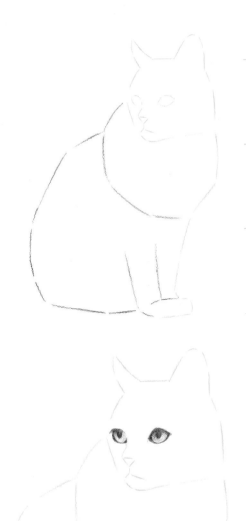

7 Shade the eyes.

FUN FACT

Almost all calico cats are female.

8 Shade the darker areas of the head.

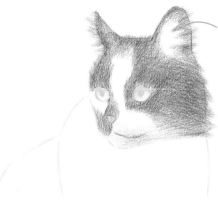

Create the shape of the lighter hairs of the ear by shading the dark interior.

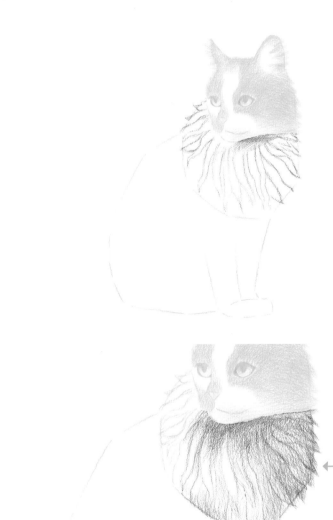

9 Sketch the sections of hairs of the ruff with wavy lines radiating outward from the upper neck.

Shade the edge with smaller strokes that form soft, irregular tips.

10 Shade under the cat's chin and on the right side of the ruff.

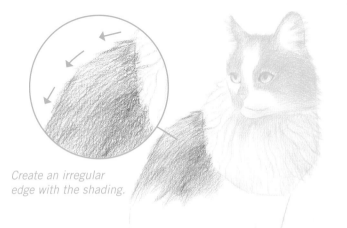

Create an irregular edge with the shading.

11 Shade the thick hair on the back in sections at slightly different angles.

12 Shade softly around the rear leg, under the ruff, on portions of the front legs, the tail, and the shadow below.

Leave these areas the white of the page.

13 Darken the shading of the ears and the top of the head with short strokes.

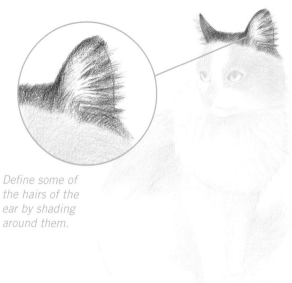

Define some of the hairs of the ear by shading around them.

14 Shade the details of the forehead, eyes, nose, and muzzle.

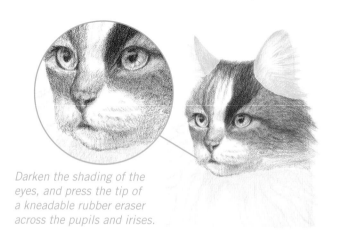

Darken the shading of the eyes, and press the tip of a kneadable rubber eraser across the pupils and irises.

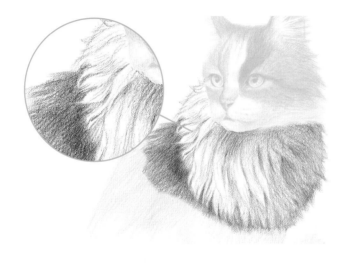

15 Define the sections of the ruff by shading the parts around the lighter ones.

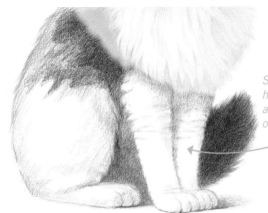

Shade an irregular, horizontal pattern across the upper part of the front legs.

16 Shade the irregular markings of the back, followed by the tail and the front legs.

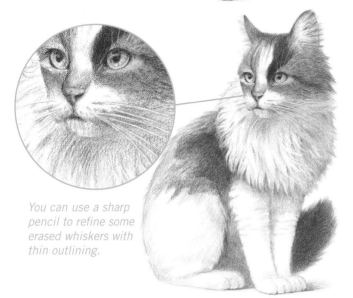

You can use a sharp pencil to refine some erased whiskers with thin outlining.

17 Using a kneadable rubber eraser shaped into a sharp edge, erase the whiskers.

labrador retriever

Steps: 17

Difficulty: ○ ○ ○ ○ ○

Labrador Retrievers are highly intelligent, easy to train, and one of the most popular dog breeds. They are faithful family pets and have loads of energy for romping around outdoors and fetching tennis balls.

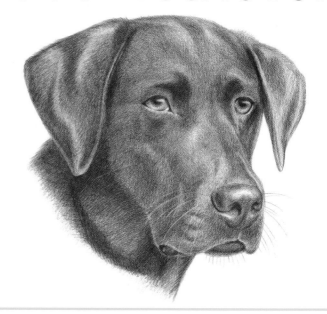

1 Lightly draw a 7½-inch (19cm) square, and add diagonal lines from corner to corner. Sketch the main shapes of the dog's head inside the box.

2 Add the main shapes of the eyes, nose, and mouth.

Draw the parts in relation to the square and diagonals.

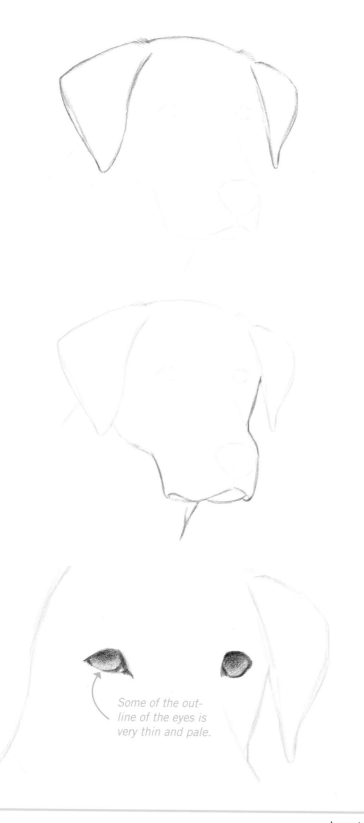

*Some of the out-
line of the eyes is
very thin and pale.*

3 Erase the square
and diagonals, and
smooth the outlines
of the top of the
head and the ears.

4 Smooth the out-
lines of the right
and lower sides of
the dog's head.

5 Shade the dog's
eyes, and refine
the outline of
the eyelids.

6 Shade the pupils darker, and erase a highlight from each eye.

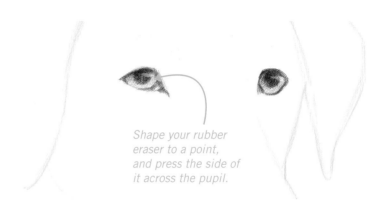

Shape your rubber eraser to a point, and press the side of it across the pupil.

7 Shade the entire head an even, medium-gray tone with short strokes.

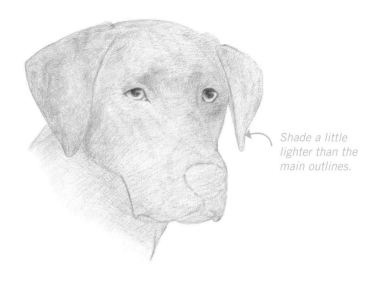

Shade a little lighter than the main outlines.

8 Shade the darker areas of the head.

Touch parts of the dog's nose with a rubber eraser to create highlights.

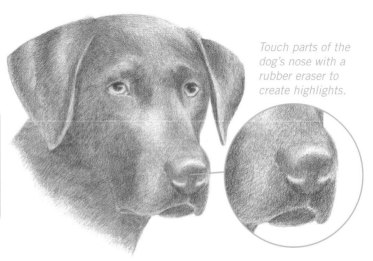

FUN FACT

Labrador Retrievers are mouth-oriented dogs and love carrying things in their mouths and chewing.

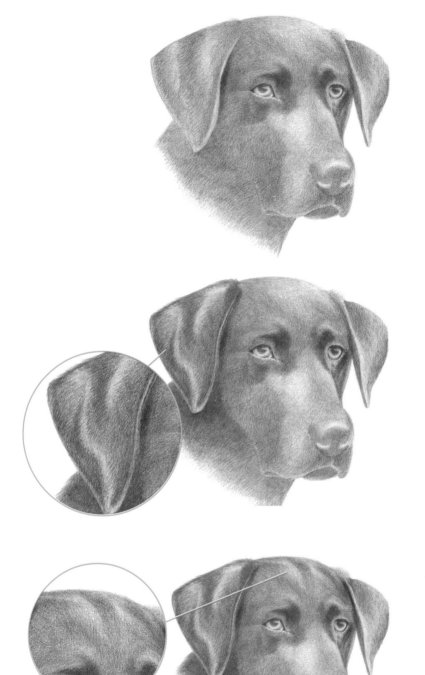

9 Shade the darkest parts around the dog's eyes and at the sides of its head.

10 Shade the darker shadow shapes of the ear on the left with short strokes. Add fur texture to the top edge.

11 Shade the darker shadow shapes of the dog's forehead.

The dark areas curve downward to the right.

12 Add darker shading and hair texture to the ear on the right.

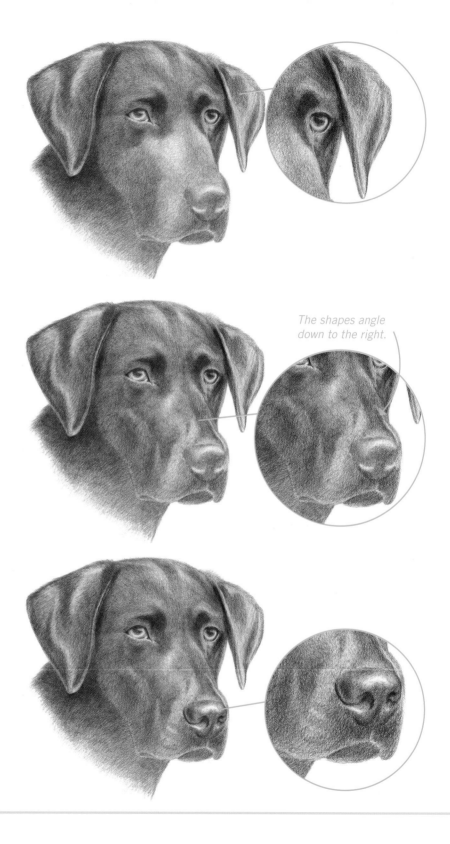

13 Shade darker areas of the muzzle.

The shapes angle down to the right.

14 Shade the details of the nose.

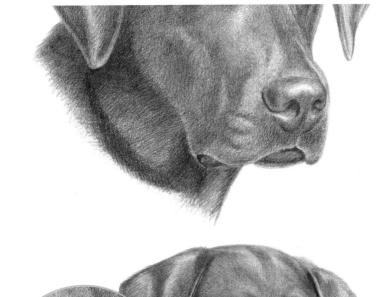

15 Shade the details of the dog's muzzle, lips, and neck.

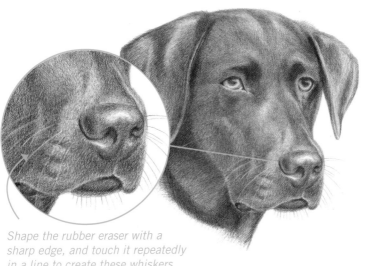

Shape the rubber eraser with a sharp edge, and touch it repeatedly in a line to create these whiskers.

16 Add the whiskers by erasing them on the left and drawing them on the right.

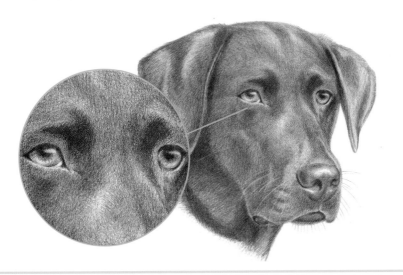

17 Darken the pupils, and add texture to the iris. Add texture to the dark eyebrow shapes, too.

saint bernard

Steps: 16
Difficulty: ○ ○ ○ ○ ○

The Saint Bernard is a very large and friendly breed of dog. Its thick coat originally protected it from the snow of the Swiss Alps. This dog has long hair, but a shorthair variety is also popular.

1 Make four short lines to mark vertical sections 2 inches (5cm) apart on the right half of your paper.

Keep these lines light so they're easy to erase or shade over later.

2 Using the marks you made in step 1, draw the main edges of the dog's head. Draw short repeating lines at the left to indicate the thick neck fur.

At this angle, the dog's head is nearly a square, and it's slightly wider than it is tall.

3 Draw the shape of the dog's back and chest with broken lines.

4 Complete the main shapes of the dog's body.

5 Draw the angled edges of the dog's upper eyelids, nose, and mouth.

6 Draw light outlines of the dark fur, mouth, and tongue and then shade them.

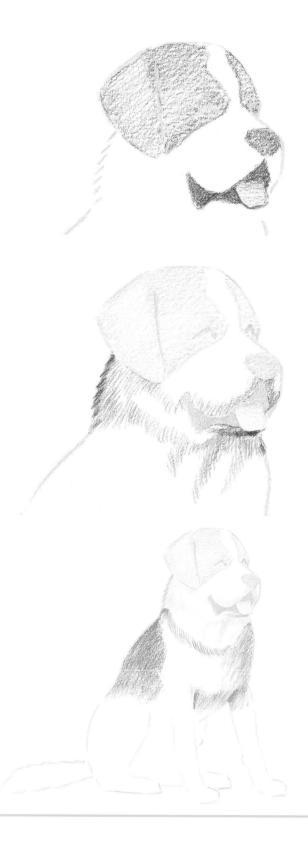

7 Shade the dog's muzzle and neck with short repeating lines.

8 Shade the dark fur on the dog's back as well as the shadow on the light fur of the dog's chest.

FUN FACT

Adult Saint Bernards can weigh up to 200 pounds (90kg).

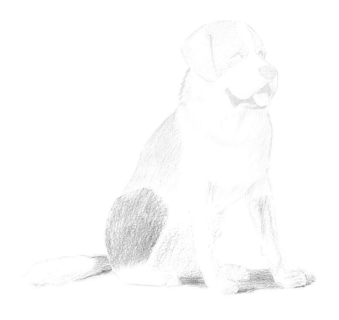

9 Continue shading the light and dark areas of the dog's body and add the shadow.

Leave lighter areas on the ear, the forehead, and beneath the eyes.

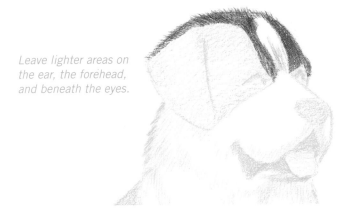

10 Intensify the shading on the head, and add fur texture at the edge with short, thin strokes.

Leave a thin area of light shading beneath the pupil.

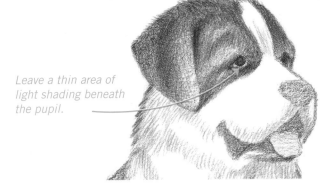

11 Draw the pupils of the eyes, and add the dark shading of the lower lid.

12 Detail the nose with short dark lines at the side and center, and add the nostrils. Darken part of the dog's mouth, and shade the tongue.

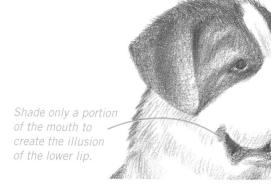

Shade only a portion of the mouth to create the illusion of the lower lip.

13 Darken the shading of the dog's back, and add angled shading to the chest.

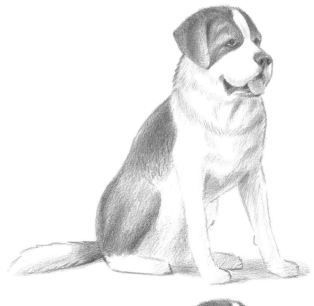

14 Add dark details to the dog's tail and rear leg, and the feathery hair of the front legs. Detail the shadow, too.

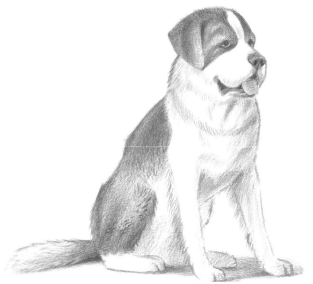

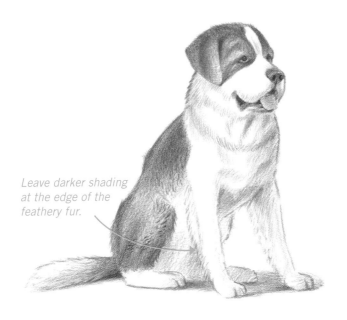

Leave darker shading at the edge of the feathery fur.

15 Erase some of the feathery hair of the front legs.

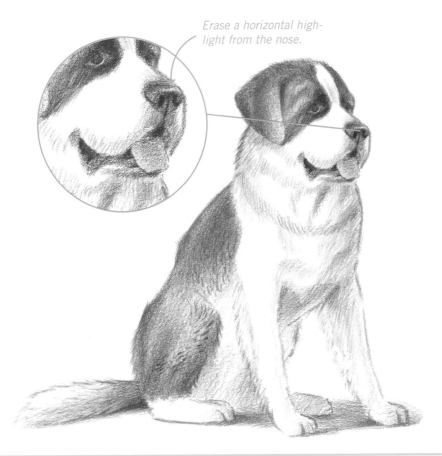

Erase a horizontal highlight from the nose.

16 Add the darkest shading angling at the dog's eyebrows, nostrils, and mouth.

american quarter horse

Steps: 17
Difficulty: ○ ○ ○ ○ ○

The American quarter horse is a muscular, fast breed with a mind for moving among cattle in herds. The breed is still used for driving cattle, ranch work, rodeos, shows, and racing—including the sprinting and quick turns of barrel racing.

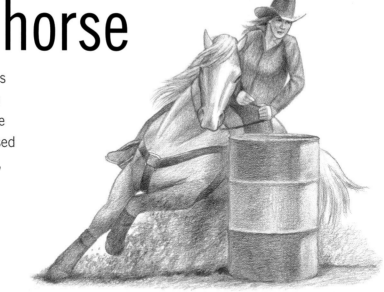

1 Draw a rectangle 2¼ inches (6cm) wide and 3¾ inches (9.5cm) tall with two horizontal interior lines.

When drawing the rectangle, curve the top line up and the interior and bottom lines down.

2 Draw the outlines of the rider's arm and hand. Add two lines that angle down and to the right.

These two lengths are equal.

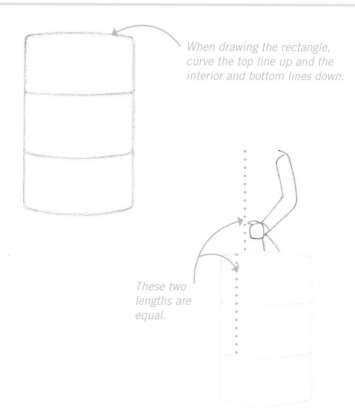

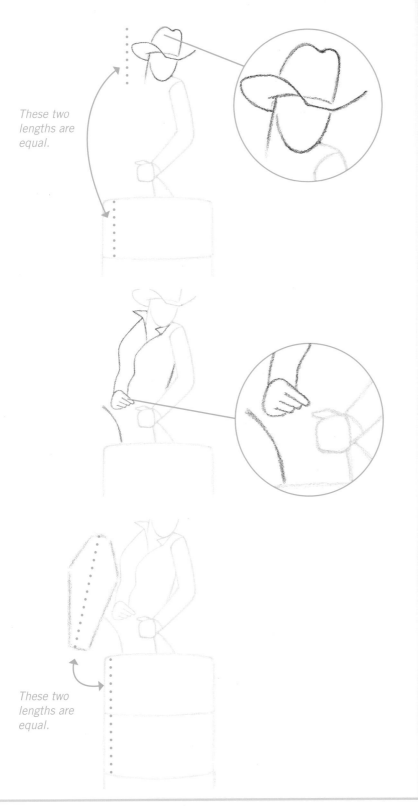

These two lengths are equal.

These two lengths are equal.

3 Draw the rider's head and hat.

4 Draw the rider's torso and hand and the curve of the saddle.

5 Sketch the basic shape of the horse's head angling to the right.

6 Draw the horse's ears, forelock, eyes, and cheeks over the basic shape of the head.

7 Complete the horse's nostrils and muzzle.

8 Draw the main lines of the horse's neck, torso, and front leg. Draw a circle where the knee will begin.

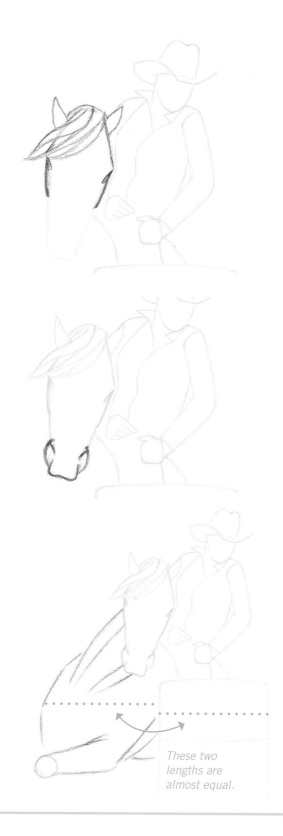

These two lengths are almost equal.

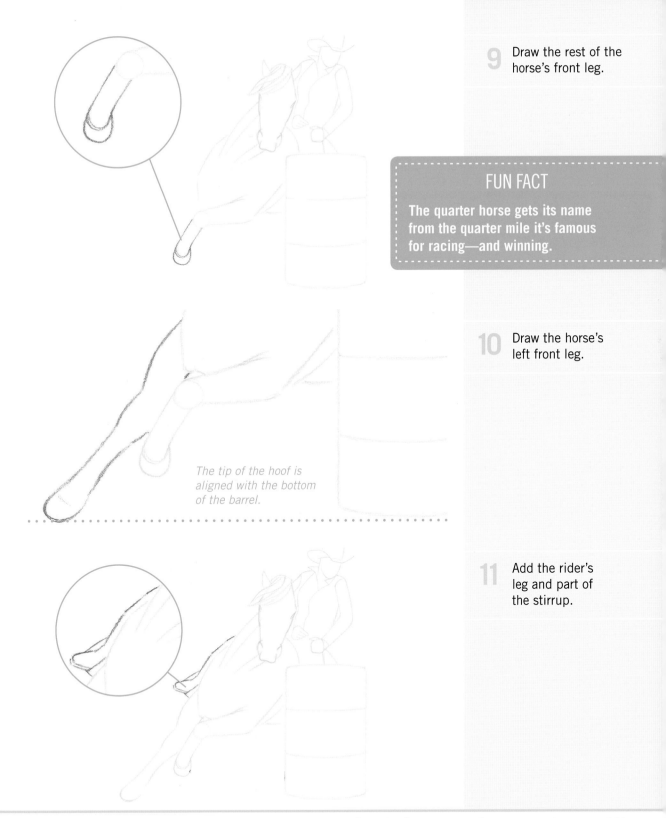

9 Draw the rest of the horse's front leg.

FUN FACT

The quarter horse gets its name from the quarter mile it's famous for racing—and winning.

10 Draw the horse's left front leg.

The tip of the hoof is aligned with the bottom of the barrel.

11 Add the rider's leg and part of the stirrup.

12 Draw the straps and buckle of the horse's breast collar.

13 Draw the main curves of the horse's tail behind the barrel.

14 Draw the rider's facial features, and shade the hat and hair.

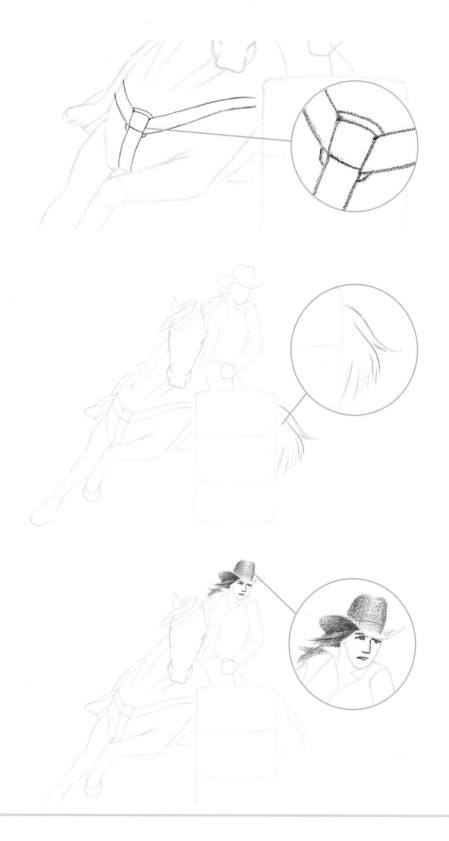

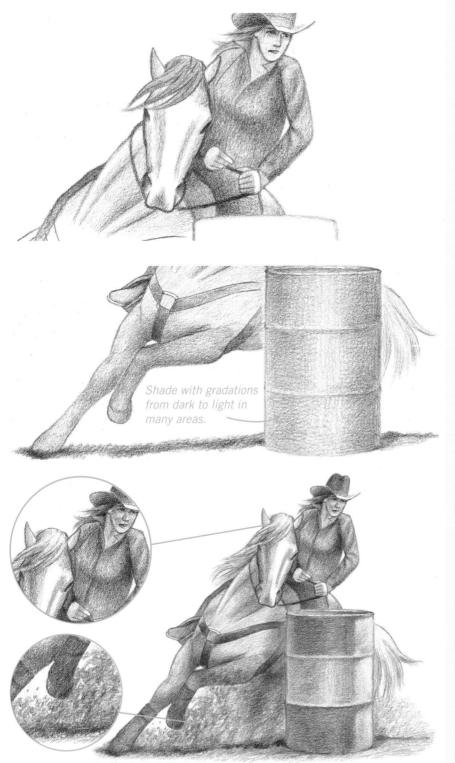

15 Shade the rider's face, neck, shirt, pants, hands, reins, and leg as well as the upper parts of the horse.

16 Shade the rest of the horse, the barrel, and the shadow below.

Shade with gradations from dark to light in many areas.

17 Shade the irregular pattern of the dust cloud, and intensify the shading of the horse, rider, and barrel. Erase highlights.